Zumthor sehen.
Bilder von Hans Danuser

Seeing Zumthor.
Images by Hans Danuser

Hans Danuser Köbi Gantenbein Philip Ursprung

Zumthor sehen.
Bilder von Hans Danuser

Seeing Zumthor.
Images by Hans Danuser

Edition Hochparterre bei Scheidegger & Spiess

Zumthor sehen. Bilder von Hans Danuser
Zwanzig Jahre später

Auch Bilder schreiben Geschichte. 1988 zeigte Hans Danuser zum ersten Mal die Bilder, die er im Auftrag des Architekten Peter Zumthor fotografiert hatte: das Atelier des Architekten in Haldenstein, die Schutzbauten über den römischen Funden in Chur und die Kapelle Sogn Benedetg in der Surselva. Als Carte blanche des Architekten an den Fotografen entstanden, waren sie zuerst in Ausstellungen und in einem Katalog zu sehen. Dann reisten sie in Zeitschriften und Büchern um die Welt. Diese Bilder setzten einen Markstein in der Geschichte der Architekturfotografie: Sie entspringen dem radikal subjektiven Blick des einen Künstlers auf die Bauten des anderen. Und: Auf ihnen schien nicht die Sonne, sondern es gab Nebel.
Zwanzig Jahre später sind diese Fotografien in der Ausstellung *Gebaute Bilder – Architektur und Fotografie in Graubünden* im Gelben Haus in Flims wieder öffentlich zu sehen. Nebst einer neueren Serie von Hans Danuser über Zumthors Therme von Vals. Sie lösten eine Debatte aus über Bilder, Bauten und Geschichte, die die Inspiration zu diesem Buch war.

Das Buch ermöglicht einen neuen Blick auf Hans Danusers Bilder. Der Fotograf liess sich damals auf diese Aufgabe ein, obwohl er sagt: «Der Plan und das Modell sind die Medien, Architektur angemessen darzustellen.» Im Gespräch mit Köbi Gantenbein, Chefredaktor der Zeitschrift *Hochparterre*, erzählt Hans Danuser von den Hintergründen, vor denen seine Bilder entstanden. Philip Ursprung, Professor für Kunstgeschichte an der Universität Zürich, erläutert in seinem Essay die Auswirkungen, die Danusers Bilder auf die Darstellung der Architektur in der Fotografie hatten.

Köbi Gantenbein

Zumthor sehen. Bilder von Hans Danuser ist das erste Buch der *Edition Hochparterre bei Scheidegger & Spiess*. Ihre Herausgeber Köbi Gantenbein und Thomas Kramer werden massgebende Beiträge zu Architektur, Design und Landschaftsarchitektur aus der Schweiz vorstellen und in die Welt hinaustragen.

Seeing Zumthor. Images by Hans Danuser
Twenty Years Later

Photographs can make history too. In 1988 Hans Danuser first presented the results of a job commissioned by the architect Peter Zumthor: views of the architect's studio in Haldenstein, shelters for the Roman archaeological site in Chur, and the Sogn Benedetg Chapel in the Surselva district. Having been given carte blanche by the architect, the photographer didn't reveal his work until the opening of the exhibition and publication of the catalogue. Immediately, the images circled the globe in journals and books and set a precedent in the history of architectural photography: images that derived from one artist's radically subjective view of the other artist's buildings. And in them the sun wasn't shining, it was foggy. Twenty years later these photographs were again shown in the exhibition *Built Pictures – Architecture and Photography in Grisons* at Das Gelbe Haus

in Flims, along with one of Hans Danuser's more recent series of Zumthor's Therme Vals. They sparked the debate on images, buildings, and history that has inspired this book.
The book offers a new view of Hans Danuser's work. The photographer took on this task back then although according to him "the plan and the model are the right media for representing architecture." In a conversation with Köbi Gantenbein, editor in chief of the journal *Hochparterre*, Hans Danuser tells us how these images came about. In his essay, Philip Ursprung, professor of art history at the University of Zurich, talks about the impact Danuser's images have had on the representation of architecture in photography.

Köbi Gantenbein

Seeing Zumthor. Images by Hans Danuser is the first book in the series *Edition Hochparterre by Scheidegger & Spiess*. Its editors, Köbi Gantenbein and Thomas Kramer, will be presenting influential Swiss-made contributions to architecture, design, and landscape architecture and sending them out into the world.

Kapelle Sogn Benedetg in Sumvitg

Bilder von Hans Danuser

Sogn Benedetg Chapel in Sumvitg

Images by Hans Danuser

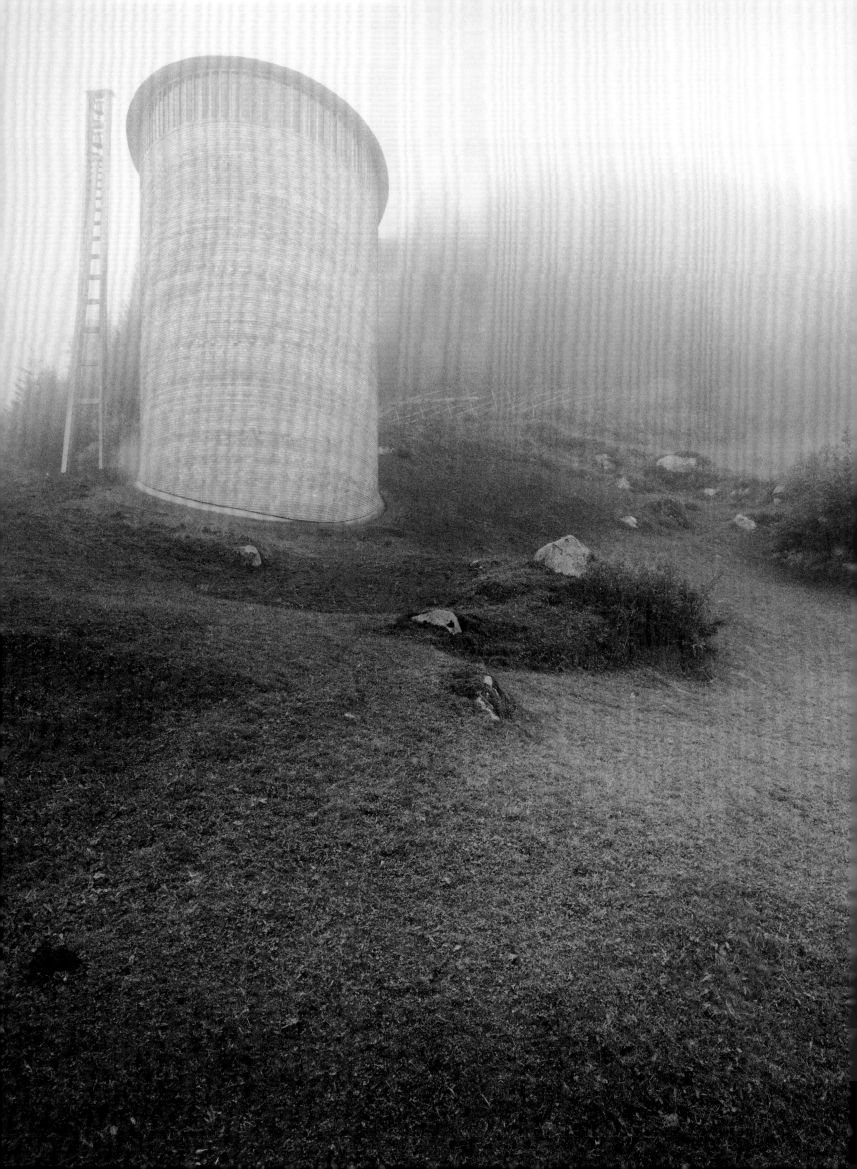

I

II

1 2

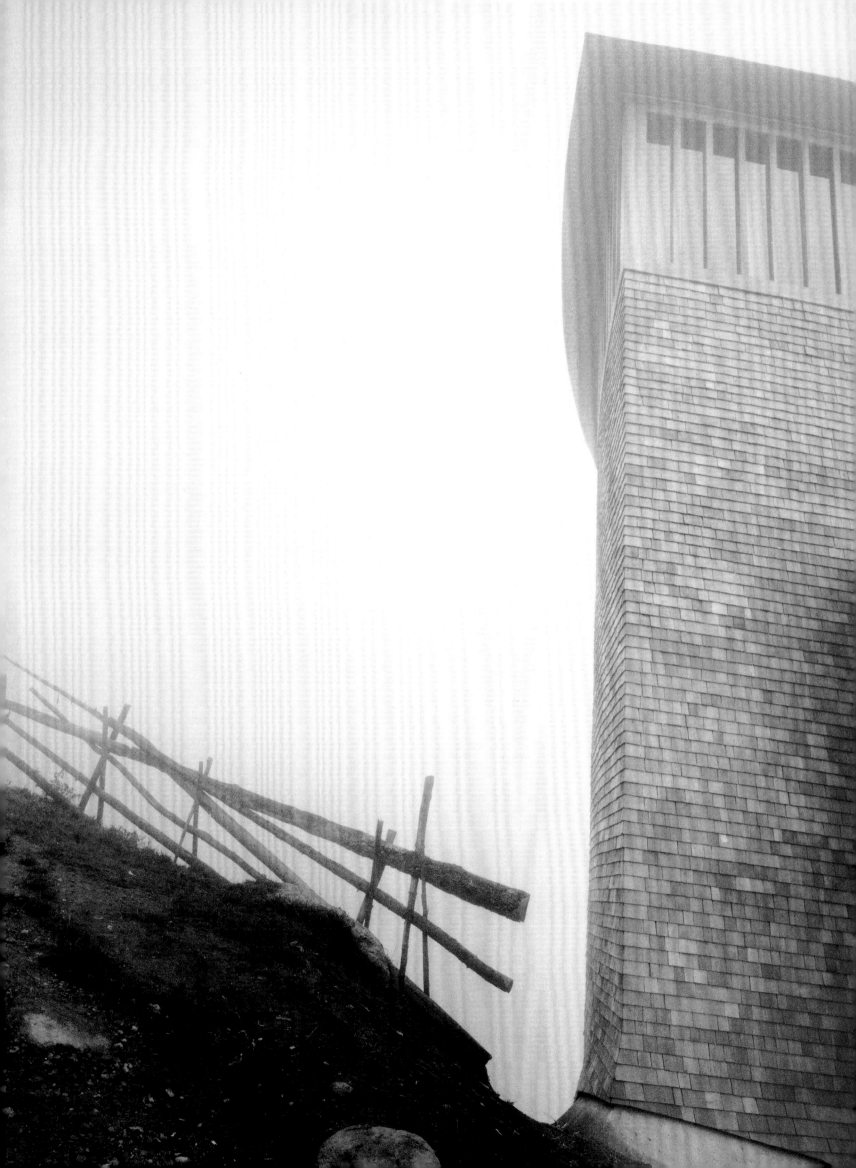

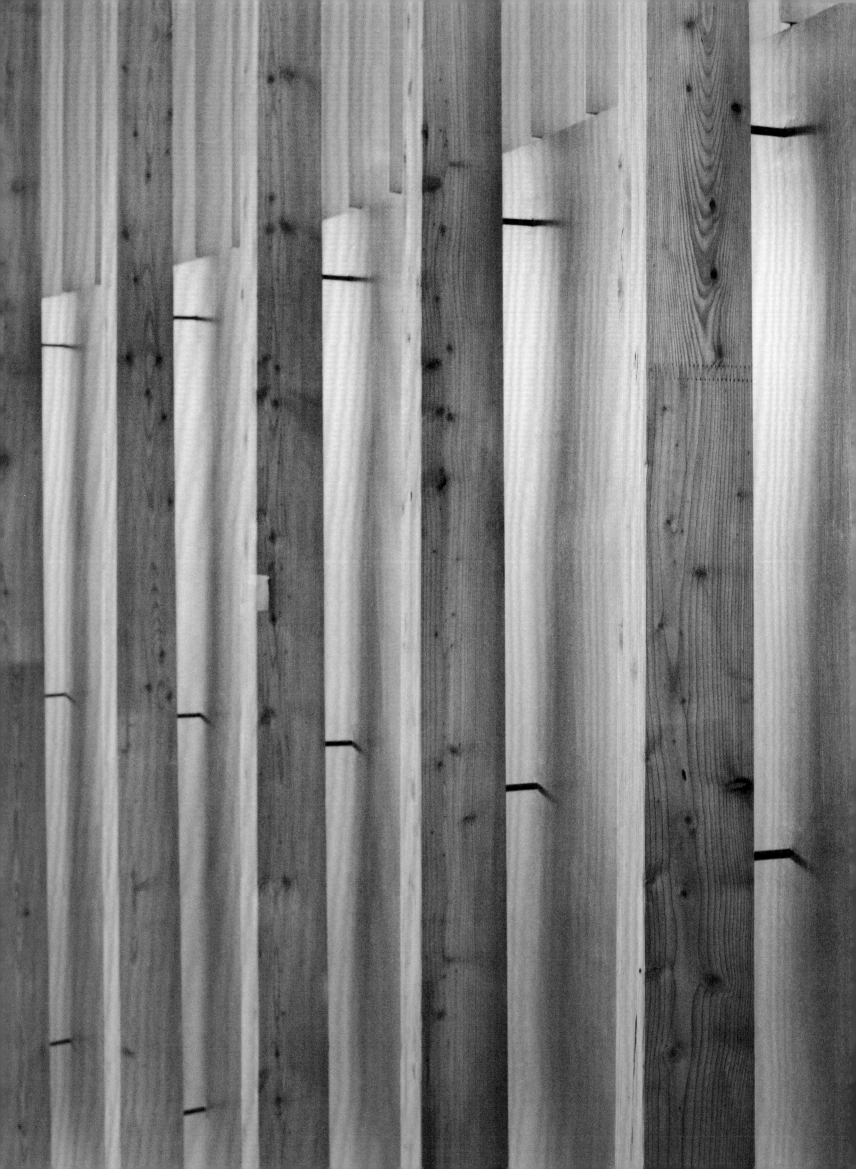

IV
1 2

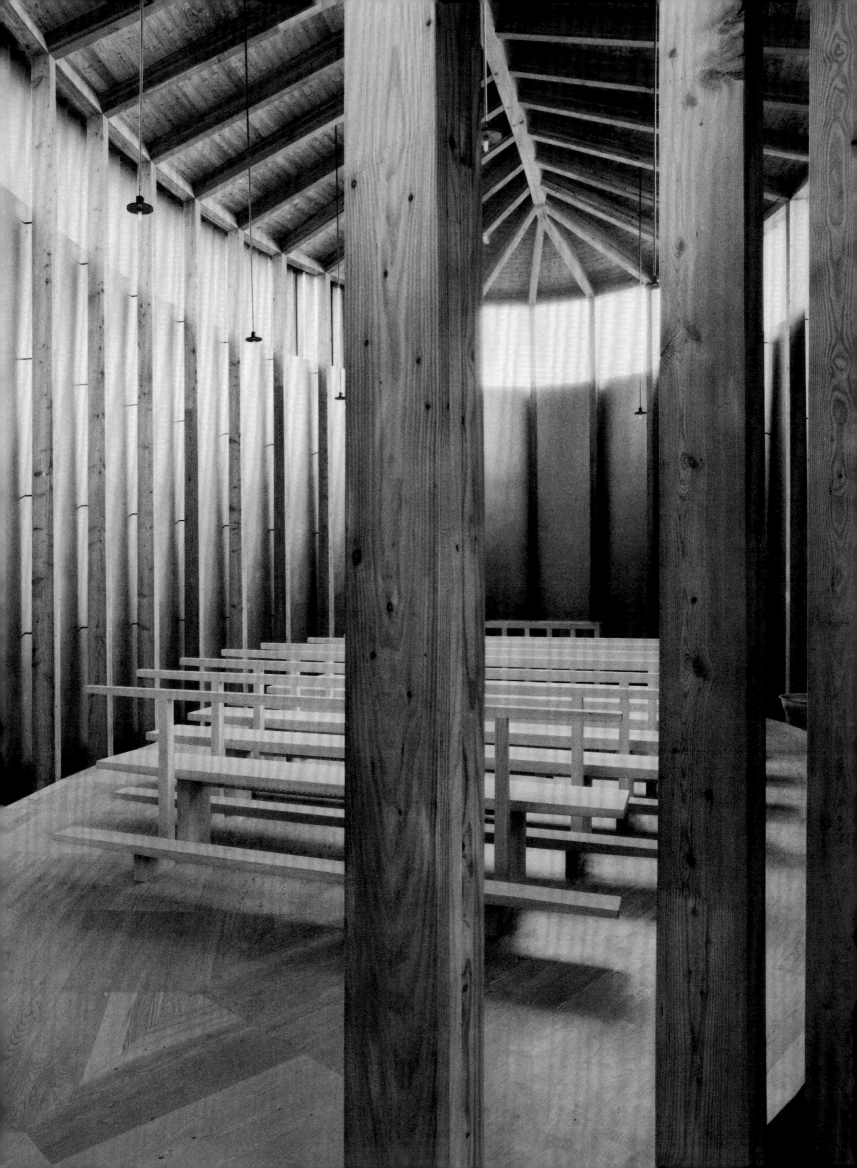

CAPLUTTA SOGN BENEDETG, SUMVITG, Fotografien auf Baryt-
papier, 6-teilig, I, II 1-2, III, IV 1-2, je auf Papierformat
50 x 40 cm, 1988

SOGN BENEDETG CHAPEL, SUMVITG, photographs on baryt
paper, 6 parts, I, II 1-2, III, IV 1-2, format of each print
50 x 40 cm, 1988

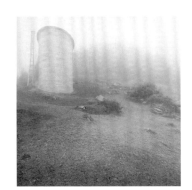

I

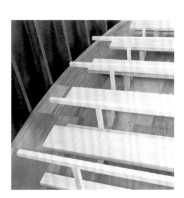

II

1 2

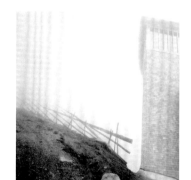

III

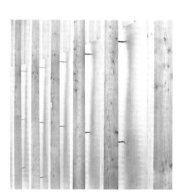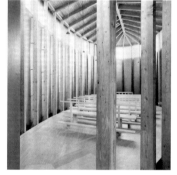

IV

1 2

Bilder bauen

Köbi Gantenbein im Gespräch mit Hans Danuser

Building Pictures

Köbi Gantenbein in Conversation with Hans Danuser

Köbi Gantenbein: Ende der 1980er-Jahre war fröhliches Babylon in der Architektur. Peter Zumthors bodenständige Bauten neben den furiosen Zeichnungen der Dekonstruktivisten; Norman Fosters Hightech-Rekorde neben einer bunten Vielfalt von Einfamilienhäusern; postmoderne Steinpaläste neben explodierenden Städten. Wie hast du die Architektur jener Jahre erlebt?

Hans Danuser: Ich lebte und arbeitete in einer sehr einfachen Wohnung mit Holzofen in Zürich. Frag mich nicht nach dem Architekten dieses Altbaus. Ich war auf meine Fotografie konzentriert, hatte aber über das Gastatelier der Stadt Zürich in New York ersten Zugang zu dem, was Architektur und Städtebau auch sein könnte, und über meine Arbeit an IN VIVO[1], die ich Ende der 1970er-Jahre begann und an der ich über zehn Jahre arbeitete, kannte ich die Industrie-Architektur und besonders deren Innenräume. Die Fotografien zeigen Werkstätten, Produktionsstätten, Labors und Denkräume. Räume,

1 IN VIVO, 93 Fotografien auf Barytpapier, je auf Papierformat 50 x 40 cm, 1980-1989

in denen damals an der Zukunft gearbeitet wurde. Ganz selten habe ich mit Aussenräumen gearbeitet und wenn, dann nur mit der Sicht von aussen auf das Objekt selbst.

Köbi Gantenbein: Neben Erfahrungen im Alltag und wachsender Neugier hattest du als Künstler gewiss unmittelbar Erfahrungen mit Architektur. Du hast Ausstellungen eingerichtet. Ausstellungen installieren heisst: mit Bildern Räume bauen. Wie haben diese Erfahrungen dein Verhältnis zur Architektur geprägt?

Hans Danuser: Diese Erfahrungen waren wesentlich. Schon nach meinen ersten Ausstellungen zeigte sich mir der Einfluss, den die Architektur und der Raum auf die Betrachtung und die Rezeption eines Bildes haben, und so wurde dieses Wechselspiel von Architektur und Bild ein zentrales Thema meiner Arbeit. In Analogie zum Feldversuch in den Naturwissenschaften, bei dem im Labor Entwickeltes einer neuen Umgebung ausgesetzt und so überprüft wird, habe ich in den letzten Jahren bei Gelegenheit meine grossformatigen Bildtableaux in Ausstellungen aus der zeitgenössischen «White Cube»-Situation herausgelöst und Architekturen vergangener Zeiten ausgesetzt. Ein interessantes Beispiel dazu ist meine Installation FROZEN EMBRYO

Köbi Gantenbein: At the end of the 1980s, architecture was a carefree Babylon. Peter Zumthor's down-to-earth buildings existed side by side with the furious drawings of the deconstructivists; Norman Foster's high-tech records next to a colorful array of single-family dwellings; postmodern stone palaces alongside exploding cities. How did you experience architecture during this time?

Hans Danuser: I lived and worked in Zurich in a very simple apartment with a wood-burning stove. It was an old building, but don't ask me who the architect was. I was completely focused on my photography. The City of Zurich sponsored a visiting artist studio in New York, and it was through this scholarship that I first had access to what architecture and urban planning could be, and through my work on IN VIVO[1], which I started in the late seventies and continued to work on for more than ten years, I became familiar with industrial ar-

1 IN VIVO, 93 photographs on baryt paper, format of each print: 50 x 40 cm, 1980-1989

chitecture and especially its interior spaces. The photographs show studios, production sites, laboratories, and spaces for thinking. Spaces where back then people were working on the future. I very rarely worked with exterior spaces, and when I did, my view was always an outside one of the object itself.

Köbi Gantenbein: Along with your everyday experiences and growing curiosity you must have also had direct experiences with architecture as an artist. You installed exhibitions, which essentially entailed building spaces with pictures. How have these experiences shaped your relationship to architecture?

Hans Danuser: Those were key experiences. After my first exhibition I realized how much architecture and space influence the viewing and reception of a picture, thus this interplay between the architecture and the photograph became a central

SERIES III[2] in der permanenten Sammlung des Bündner Kunstmuseums. Die drei Fotografien sind im Lichthof der klassizistischen Villa als Fries auf die in Marmorstruktur ausgemalten Wände appliziert. Sie bilden auf drei Seiten eine Abgrenzung über der Treppe. Von der Decke kommt das helle Licht, von unten das dunkle Licht. Die repräsentative Architektur aus dem 19. Jahrhundert in wuchtigem Stuck und Sandstein wird zu einem prägnanten Kontrast für die helldunklen Bildtableaux. Dass Bilder ihrerseits die Wahrnehmung von Architektur verändern, habe ich eindrücklich erfahren, als ich 2001 meine Bildzyklen EROSION[3] für die grosse Ausstellung im Fotomuseum Winterthur am Boden auslegte. Einige regelmässige Besucher des Museums meinten, es sei umgebaut worden.

2 FROZEN EMBRYO SERIES III, 3-teilig, Fotografie auf Barytpapier, je auf Papierformat 150 x 140 cm, 1998–2000

3 EROSION I–VII, mehrteilige Bodeninstallation, Fotografien auf Barytpapier, je auf Papierformat 150 x 140 cm, aufgezogen auf Alu 2 mm, 2000–2006

Köbi Gantenbein: Dies führt mich zur Ausstellung *Partituren und Bilder: Architektonische Arbeiten aus dem Atelier Peter Zumthor 1985–1988*, der ersten öffentlichen Präsentation der Architektur von Peter Zumthor. Noch während der Ausstellung in der Architekturgalerie Luzern 1988 und der zweiten Station in Graz gingen die Bilder der Kapelle durch Publikation in internationalen Architektur-Zeitschriften wie *Domus* oder *Ottagono* um die Welt. Marco Meier hat 1992 sein erstes *Du*-Heft zur Architektur der Schweiz – «Pendenzen. Neue Architektur in der deutschen Schweiz» – mit diesen Bildern gemacht. Welchen Einfluss hatte deine Arbeit zu Peter Zumthors Bauten auf Architekten und Fotografinnen?

Hans Danuser: Die ungewohnte fotografische Sichtweise hatte die Szene irritiert. Das Architekturforum Luzern führte Diskussionen durch. Andere Architekten haben in der Folge ebenfalls die Zusammenarbeit mit der freien Fotografie gesucht. Die Bedeutung der Bilder in der Rezeption der Architektur und die Medialisierung von Architektur nahmen zu; es wurden neue Bilder gesucht.

theme in my work. Analogous to the way natural scientists experiment in the field by taking something developed in the laboratory and releasing it into a new environment in order to test it, I have in recent years whenever the opportunity arose taken my large-format tableaux out of the contemporary "white cube" situation for my exhibitions and exposed them to the architecture of former times. One interesting example of this is my installation FROZEN EMBRYO SERIES III[2], which is part of the permanent collection of the Bündner Kunstmuseum. There the three photographs have been mounted as a frieze on the faux marble walls of the atrium of the classicistic villa, where they form a boundary line above the staircase on three sides. Bright light descends from the ceiling; dark light rises from below. In heavy stucco and sandstone the representative nineteenth-century architecture creates a clear contrast to the light-dark photographic tableaux. In 2001 I had an experience that really brought home the fact that pictures, too, can change the perception of architecture. Several regular vi-

sitors thought the museum had been remodeled when I laid out my series EROSION[3] as a floor installation for the large-scale exhibition at the Fotomuseum Winterthur.

Köbi Gantenbein: This brings me to the exhibition *Partituren und Bilder: Architektonische Arbeiten aus dem Atelier Peter Zumthor 1985–1988*, the first public presentation of Peter Zumthor's architecture. While the exhibition was still running at the Architekturgalerie Luzern in 1988 and during its second stop in Graz, the photos of the chapel were already circling the globe in international architectural journals like *Domus* or *Ottagono*. Marco Meier used the images in his first issue published in *Du*, which was a special

2 FROZEN EMBRYO SERIES III, 3 parts, photograph on baryt paper, format of each print: 150 x 140 cm, 1998–2000

3 EROSION I–VII, multi-part floor installation, photographs on baryt paper, format of each print: 150 x 140 cm, mounted on aluminum 2 mm, 2000–2006

Köbi Gantenbein: Ich habe damals deine Fotografien zu den ersten drei Bauten von Peter Zumthor in der Architekturgalerie Luzern gesehen: die Schutzbauten über den römischen Ruinen von Chur, das Atelier des Architekten und die Kapelle von Sogn Benedetg. Wie kam es zu diesen Fotografien?

Hans Danuser: Anlässlich meiner ersten Ausstellung im Bündner Kunstmuseum, wo Beat Stutzer meine ersten drei abgeschlossenen Serien aus dem Bildzyklus IN VIVO zeigte, hat mich Peter Zumthor auch wegen dieser Raumansichten auf eine mögliche Zusammenarbeit angesprochen. Das war Mitte der 1980er-Jahre, und von da an habe ich seine Anfänge in der Architektur näher betrachtet. Mir schien, er wolle die Architektur neu erfinden, analog also zu dem, was ich in der Fotografie suchte. Meine professionelle Auseinandersetzung mit den Bauten Zumthors war für mich dann der erste konzentrierte Einstieg in die Architektur und in deren Bildfindungen.

Aber vielleicht sollten wir zuerst eine kleine Reise in die Situation und Befindlichkeit der Fotografie jener Zeit machen. In den 1970er-Jahren war die Fotografie an einem Punkt angekommen, an dem sie nicht mehr wusste, wo sie stand. Das Fernsehen löste die lange gehaltene Kernkompetenz der fotografischen Reportage für dokumentarische Wahrhaftigkeit und Verbindlichkeit ab. Die Fotografie, so möchte ich in der Sprache der 1970er-Jahre sagen, war instrumentalisiert, das heisst, sie wurde nur noch zur Illustration verschiedenster Inhalte ge- oder missbraucht. Dennoch gab es keine Zeit vorher, die so viele fotografische Bilder hervorgebracht hat. Aber nur ein fotografischer Bereich in dieser Zeit war aufregend und spannend, nämlich die Werbung. Jene Jahre waren eine Hochblüte für die Fotografie in der Werbung. Ich konnte mir in dieser Zeit als Assistent beim deutschen Werbe- und Modefotografen Michael Lieb in Zürich das Handwerk des Fotografen erarbeiten.

Köbi Gantenbein: Ich habe dem einen Akzent beizufügen. Die technische Entwicklung war der Motor. Die neuen Litho- und Druckmaschinen motivierten die Werbeleute zu Höhenflügen. Die neuen Apparate erlaubten, dass sie vollflächig und kostengünstig

focus on Swiss architecture. How did your work on Peter Zumthor's buildings influence architects and photographers?

Hans Danuser: My unusual photographic perspective had an unsettling effect on the scene. There were discussions at the Architekturforum Luzern. It got some architects interested in collaborating with independent photographers. The importance of images in the reception and mediatization of architecture increased; people wanted new images.

Köbi Gantenbein: Back then, I saw your photographs on Peter Zumthor's first three buildings at the Architekturgalerie Luzern: the protective structures for the Roman ruins in Chur, the architect's studio, and Sogn Benedetg Chapel. What led up to these photographs?

Hans Danuser: My first exhibition was at the Bündner Kunstmuseum, where Beat Stutzer presented my first three completed work series from the IN VIVO cycle. That was where Peter Zumthor approached me about potentially collaborating in the future, no doubt in part because of the spatial views. That was the mid 1980s, and from then on I paid closer attention to this early period of his architectural career. It seemed to me as if he were trying to reinvent architecture, in much the same way as I was trying to do in photography. My profes-

sional examination of Zumthor's buildings was my first concentrated foray into architecture and its pictorial composition.

But maybe we should take a little trip back in time and start with the situation and zeitgeist of photography in the 1970s. Back then, photography had reached a point where it no longer knew where it stood. Television had supplanted what had long been considered the core competency of photographic reportage in terms of documentary veracity and reliability. Photography, to use the vocabulary of the 1970s, was instrumentalized, that is to say it was only being used or abused to illustrate various subject matter. No period before had ever brought forth so many photographic images, and yet at the time there was just one field in photography that was charged with energy and truly exciting: advertising. Those years were a heyday for commercial photography. During that time I worked as an assistant for the German advertising and fashion photographer Michael Lieb in Zurich, where I was able to learn the trade.

mit vier Farben in den Zeitschriften auftreten konnten. Die Redaktionen haben diese Entwicklung aber ebenfalls genutzt: Alles wurde farbig. Und die Art Direktoren übertrugen bald darauf die Fotografien in den Computer, wo sie sie mit wenig Aufwand zerschneiden, neu zusammensetzen, verdunkeln, aufhellen oder sogar ganz und gar verändern konnten. Stimmt bei so viel Betriebsamkeit das Bild vom Endpunkt, an dem die Fotografie angelangt sein sollte?

Hans Danuser: Die Erweiterung der Technik ist natürlich massgebend für die Entwicklung der Fotografie. Der Diskurs aber kümmert sich auch um Inhalte und um die Position gegenüber der eigenen Zeit. Robert Frank sagte damals: Die Fotografie ist tot. Er konzentrierte sich in der Folge für viele Jahre auf den Film. Als Künstler hatte er gespürt, dass die damalige Fotografie ihrer Zeit nichts mehr zu sagen hatte. Die traditionelle Reportagefotografie, die ihren Höhepunkt in den 1950er-Jahren erlebte, war ausgelaugt und hatte dann noch eine Nische im Feuilleton gefunden. Ihre Zeit war ganz einfach vorbei. Und in der Kunst hatte Fotografie keinen autonomen Platz; diese konzentrierte sich auf die Malerei. Wenn von einem «Bild» die Rede war, war Malerei gemeint, und wer von einem «Abbild» sprach, meinte Fotografie. Diese Konstellation war für mich eine optimale Ausgangslage, konnte ich doch die Fotografie für mich neu erfinden. So muss sich Livingstone gefühlt haben, als er ins Innere Afrikas aufbrach und eine für uns Europäer weisse Landkarte betrat. Die 1980er-Jahre waren dann – nicht nur für mich – die Zeit der Entdeckung der freien Fotografie.

Köbi Gantenbein: Du beschreibst deinen Weg als Distanzierung zur Malerei, zu gängigen fotografischen Verfahren und als Suche nach dem weissen Fleck auf der Landkarte. Jeder Bilderbauer hat Ankerstellen. Worauf hast du deine Bildfindung gestützt?

Hans Danuser: Auf die Literatur, die Sprachwerkstatt. Fotografie hat eine hohe Kompetenz im Beschreiben und Aufzeichnen von Dingen und Situationen, analog zur beschreibenden Sprache in der Literatur. Mich hat die Literatur als Referenz interessiert. Das Beschreiben des Sichtbaren mit Worten und das Aufzeichnen des Sichtbaren mit Foto-

Köbi Gantenbein: In this context I'd also like to stress that the driving force came from the technological advances. The new litho and printing presses inspired ad people to creative heights. The new machines let them place full-page, four-color ads in newspapers for affordable prices. But the editors also took advantage of the new technology, so suddenly everything was in color. And it wasn't long before the art directors were uploading photographs to their computers, where with little effort they could cut them up and paste them back together, make them darker or lighter, or alter the images completely. In the midst of all this, was there any truth in the view that photography had reached the end of the line?

Hans Danuser: Technological advances are of course crucial to the development of photography. But the discourse also addresses content and one's position to the events and developments of one's time. Back then, Robert Frank said: photography is dead, and for many years after that he concentrated on film. As artist he felt that the photography of his day had nothing left to tell its era. Traditional reportage photography, which had reached its zenith by the 1950s had become jaded and found its niche in the feuilleton. Its time had simply passed. Photography didn't have its own place in art because art concentrated all its attention on painting. If one spoke of a "bild" [signifying picture in the sense of an original work], one meant painting, whereas to refer to photography one used the word "abbild" [meaning image, literally denoting the copy of a "bild"]. For me this constellation was the perfect point of departure because I was able to re-invent photoggraphy for myself. I imagine this is how Livingstone must have felt when he set out into the African interior, toward what we Europeans saw as a blank map. Thus, the 1980s were a time of discovery, not only for me, but for independent photography in general.

Köbi Gantenbein: You describe your path as one of distancing yourself from painting, from conventional photographic processes, and as a search for the blank spot on

grafie, um dem Verborgenen auf die Spur zu kommen, haben viele Ähnlichkeiten. Beiden ist gemeinsam, dass sie vom Protagonisten ein genaues Betrachten voraussetzen. Die kleinste Positionsverschiebung verändert die Ansicht und die Sicht auf die Dinge. Beide umkreisen ein Ding, kreisen es ein und gelangen je nach Standort zu unterschiedlichen Wahrnehmungen.

 Köbi Gantenbein: Zwischen Literatur und Fotografie gibt es einen massgeblichen Unterschied. Literatur ist Fiktion, der Schriftsteller erfindet Räume und Geschichten; er beschreibt zwar, aber er dokumentiert nicht. Wie schaffst du da den Bogen?

Hans Danuser: Auch die Literatur hat eine beschreibende dokumentarische Kompetenz. Ich erfahre das nicht als Gegensatz. Fotografie und Literatur verbindet die Möglichkeit der Fiktionalisierung. Beschreibt eine Autorin einen Gegenstand, einen Raum oder eine Landschaft, so kann sie den Leser in eine fiktive Welt führen. Fotografie hat dieses Potenzial auch. Sie kann werten, fiktionale Räume

öffnen oder zu Spielereien einladen. Entscheidend ist – und das unterscheidet sie von den anderen Künsten – ihre dokumentarische Basis; sie kann der Fotografie und der Literatur eine ungemeine Brisanz geben. Bis zur Erfindung der Fotografie galt einzig der Augenzeugenbericht als das verbindliche Zeitdokument. Ich habe gegen Ende der 1970er-Jahre mit diesen Gemeinsamkeiten und Unterschieden in meiner Bildfindung zu arbeiten begonnen und mich dann im Bildzyklus IN VIVO auch vom Einzelbild zur Bildgruppe bewegt. Nicht inhaltlich begründet, wie die damalige Reportagefotografie es in einer «Wenn, dann»-Abfolge verlangte, sondern analog zur Grammatik der Sprache suchte ich die Bausteine für die Struktur eines Satzes, also Subjekt, Prädikat, Objekt, Adjektiv etc. So liegt jeder der sieben Serien von IN VIVO ein Satz zugrunde.

 Köbi Gantenbein: Die Bedeutung von Literatur für die Fotografie hat in den 1980er-Jahren nicht nur dich beschäftigt. Leute wie Roland Barthes in Frankreich oder Susan Sontag in den USA schrieben wegweisende Bücher. In der Schweiz haben Walter Keller oder Urs Stahel die Wahrnehmung von Fotografie verändert – sie alle sind oder waren der Literatur nahe. Deine Neugier für

the map. Every picture builder has his anchor points. What is your pictorial composition based on?

Hans Danuser: Literature, the laboratory of words. Photography is extremely well suited for describing and recording things and situations, analogous to the descriptive language of literature. I was interested in literature as a frame of reference. There are many similarities between describing the visible with words and recording the visible with photography in an attempt to get to the bottom of the hidden. One thing they share is that they both call for precise observation on the part of the protagonist. The slightest shift in position changes one's perspective and view of things. Both circle a thing, move in on it, and depending on the their position, arrive at different perceptions.

 Köbi Gantenbein: There is a major difference between literature and photography. Literature is fiction, the writer invents spaces and stories, he describes perhaps, but he doesn't document. How do you manage to bridge this gap?

Hans Danuser: Literature also has a descriptive documentary competency. I don't perceive them as opposites. Photography and literature share the

possibility of fictionalization. If a writer describes an object, a space, or a landscape, she can take the reader to a fictional world. Photography has this potential too. It can make judgments, open up fictional spaces, or invite the viewer to experiment and have fun. The key thing — and this is what sets it apart from other art forms — is its documentary basis, it can lend photography and literature enormous explosive power. Until the invention of photography, eye-witness accounts were considered the only reliable documents of the time. Towards the end of the 1970s I began working with these similarities and differences in my pictorial composition, and in my series IN VIVO I gradually went from the single picture to the group of pictures. I didn't substantiate my subject matter in an "if, then" sequence as reportage photography called for back then, but analogous to the grammar of language I searched for the building blocks, for the structure of a sentence: subject, verb, object, adjective, etc. Thus each of the seven series of IN VIVO is based on a sentence.

Literatur teilte und teilt auch Peter Zumthor. Er ist nicht nur ein Gern- und Vielleser, sondern auch ein beneidenswert guter Schreiber. Begann die Zusammenarbeit zwischen dir und Peter Zumthor über Worte?

Hans Danuser: Im Vorfeld der Zusammenarbeit führten Peter, Annalisa Zumthor und ich verschiedentlich Gespräche. Eine Voraussetzung war, dass Peter Zumthor meine Art der Fotografie wollte, und für mich war es interessant auszuloten, ob meine in der freien Fotografie und insbesondere im Bildzyklus IN VIVO erarbeitete Bildsprache sich in der Architekturfotografie anwenden liess. Um dies zu versuchen, hatten Peter Zumthor und ich eine Carte blanche vereinbart. Er sah die Bilder erst kurz bevor sie in Druck gingen und für die Ausstellung *Partituren und Bilder* [4] vorbereitet wurden. Peter ist damit sicher ein Risiko eingegangen, denn schon Mitte der 1980er-Jahre hatte die neue

4 *Partituren und Bilder: Architektonische Arbeiten aus dem Atelier Zumthor 1985–1988*, Fotografien von Hans Danuser

Generation der Architekten damit begonnen, eine absolute Bestimmungshoheit über die Architekturfotografen und deren Bilder einzufordern.

Köbi Gantenbein: Carte blanche heisst wohl kaum, dass du im luftleeren Raum vor dich hin gearbeitet hast. Schaue ich die Bilder zur Kapelle an, erzählen sie mir von einem intensiven Dialog zwischen dem Fotografen und dem Bau und zwischen dem Fotografen und dem Architekten. Wie habt ihr diese Zusammenarbeit eingerichtet?

Hans Danuser: Mein Zögern, mich auf diese Arbeit einzulassen, und mein Haupteinwand waren, dass Fotografie nicht das richtige Medium sei, um Architektur darzustellen. Meiner Meinung nach sind das der Plan und das Modell. Der Plan des Architekten zeigt dem, der ihn zu lesen versteht, alles. Ausführungs- und Übersichtspläne generieren beim Betrachter die Volumen und die Bilder der Bauten in ihrer Authentizität, ähnlich der Partitur eines Komponisten. Keine Aufführung der «Fünften» von Beethoven schöpft das Potenzial der Partitur aus; sie übersteigt immer die Möglichkeiten der Musiker und des Dirigenten. Ich bin heute noch der Meinung, dass für den Architekten der Plan die adäquate Art ist, seine Arbeit zu vermitteln – heute mögen es auch Entwurfsbilder aus dem Com-

Köbi Gantenbein: In the 1980s the significance of literature for photography was a theme that interested others in addition to yourself. People like Roland Barthes in France or Susan Sontag in the USA wrote seminal books. In Switzerland Walter Keller or Urs Stahel changed our perception of photography — all of them are or were closely tied to literature. Peter Zumthor continues to share your curiosity for literature. He is not only a passionate and avid reader but also an exceptionally good writer. Did the collaboration between Peter Zumthor and yourself begin via words?

Hans Danuser: Prior to our collaboration, Peter, Annalisa Zumthor and I had several conversations. From the outset it was clear that Peter Zumthor wanted my kind of photography, and I, for my part, was interested in finding out whether the pictorial language I had developed in independent photography and particularly in the series IN VIVO could be applied to architectural photography. To this end, Peter Zumthor and I agreed on a carte blanche. He would only get to see the pictures right before they went to press and were sent to be processed for the exhibition *Partituren und*

Bilder [4]. For Peter there was definitely risk involved here because by the mid-1980s a new generation of architects had begun to demand absolute decision-making sovereignty over the architectural photographers and their pictures.

Köbi Gantenbein: Carte blanche, of course, doesn't mean you worked alone in an isolated vacuum. When I look at the photos of the chapel, they bespeak an intense dialogue between the photographer and the building and between the photographer and the architect. How did you define your collaboration?

Hans Danuser: My reluctance to immerse myself fully in this project and my main objection were based on my conviction that photography is not the right medium for representing architecture. To me, the plan and model are. If you know how to read the architect's plan, it will tell you everything. Final and overall plans authentically

4 *Partituren und Bilder* [Scores and Images], *architectural works by Atelier Zumthor 1985–1988*, photographs by Hans Danuser

puter sein. Unübertroffen zum Verständnis der Proportionen und im Speziellen der Lichtführung ist das Modell. Ich erinnere mich an die grossartige Ausstellung im Palazzo Grassi in Venedig zur Architektur in der Renaissance, in deren Zentrum die von Michelangelo gefertigten Modelle zum Petersdom standen. Das ist für mich Architekturdarstellung. Peter Zumthor war also klar, dass ich mich fotografisch einzig auf einzelne Bereiche seiner Architektur konzentrieren wollte. Ich versuchte – um in der Sprache der Musik zu bleiben –, einzelne fotografische Klangbilder aus seinen Partituren zu generieren. Dieser Anspruch prägte auch den Titel zu Buch und Ausstellung *Partituren und Bilder*.

> Köbi Gantenbein: Peter Zumthor zeigt mit seinen Bauten seinen Sinn fürs Material und fordert von den Handwerkern viel Verarbeitungskönnen. Wie hat sein Hochamt für das Material und dessen Zusammenfügen deine Arbeiten beeinflusst?

Hans Danuser: Die Materialauthentizität seiner Bauten kam meiner Fotografie entgegen. Seine ersten drei Bauten tragen ihr Inneres auf der Haut.

Hier konnte ich meine während der Arbeit an IN VIVO entwickelte Bildsprache anwenden: das akribische Abtasten der Oberflächen. Diese fotografische Konzentration auf die Materialstruktur der Oberfläche hat mich bei allen Bauten interessiert, auch bei der später realisierten Bildserie zur Therme Vals, die in meiner langjährigen Zusammenarbeit mit dem Musiker Fritz Hauser und seinem Klangraum in der Therme entstand. Im Bildzyklus zur Therme Vals zeigt sich das Wasser einzig in nassen Spuren auf dem Boden. Für die zwei Raumansichten des Bades haben wir alles Wasser auslaufen lassen, so dass die Schichtung des Granits, der das Volumen des Bades bildet, im Bild sichtbar ist. Die Kapelle Sogn Benedetg, gebaut aus Lärche, Fichte und Esche, und später dann die Therme Vals, gebaut aus Granit, sind sicher die beiden fotografischen Arbeiten zu Architektur, die ich am radikalsten in diese Reduktion führen konnte.

> Köbi Gantenbein: Zu dieser Radikalität gehört auch eine klare Entscheidung: Warum sind all die Arbeiten in Schwarzweiss gehalten?

Hans Danuser: Um Bauten von Zumthor zu fotografieren, kam für mich nur Schwarzweiss infrage und zwar deshalb, weil seine Bauten von innen nach aussen entwickelt sind, also als Körper in Erschei-

generate the volumes and the images of the building for the viewer, like a composer's score. No performance of the Fifth of Beethoven can realize the full potential of the score, which always goes beyond what the musicians and conductor are capable of. I still believe the plan — or today also the computer-aided drawing — is the most fitting device for conveying the architect's work. And the model is unexcelled for the purpose of understanding proportions and above all lighting. I remember the fantastic exhibition on renaissance architecture shown at the Palazzo Grassi in Venice, which featured Michelangelo's model of St. Peter's Basilica. To me that is architectural representation. Peter Zumthor knew that I only wanted to concentrate on individual areas of his architecture in my photographs. What I tried to generate with my photos — to use the language of music — was individual sound pictures based on his score. This challenge influenced the title of the book and exhibition *Partituren und Bilder*.

> Köbi Gantenbein: With his buildings, Peter Zumthor demonstrates his understanding of the material and he demands a great deal from his workers in terms of handling

skills. How has his celebration of the material and the way he puts it together influenced your work?

Hans Danuser: The material authenticity of his buildings fit well with my work. The essence of his first three buildings are revealed in their exteriors. With them I was able to use the pictorial language developed during my work on IN VIVO: the meticulous inch for inch examination of the surfaces. This photographic concentration on the material structure of the surface is something that has fascinated me in all his buildings, including my later series of the Therme Vals, which came about through the many years of collaboration with the musician Fritz Hauser and his Sounding Stone. In the Therme Vals series the water is only visible in the wet traces on the ground. For the two interior views of the thermal bath we drained the pools so that all we see in the picture is the layering of granite slabs that defines the volume of the building. With the Sogn Benedetg Chap-

nung treten. Meiner Meinung nach bringt die Schwarzweiss- bzw. die Hell-Dunkel-Technik diese Körperhaftigkeit viel besser zum Ausdruck als Farbe. Sobald es sich um die Darstellung einer Architekturposition mit Gewichtung auf der Fassadengestaltung handelt, ist wiederum Farbe geeigneter. Interessant ist, dass der Transfer von Objektoberflächen ins fotografische Bild nur in der Hell-Dunkel-Technik respektive im Spektrum der Grauwerte vom hellsten Hell bis zum dunkelsten Dunkel so funktioniert, dass der Bau als Körper spürbar wird. Sobald Farbfotografie ins Spiel kommt, fällt die Durchlässigkeit der Oberflächen weg und damit die Tiefe des Bildes in sich zusammen. Es ist verhext: Die Augen des Betrachters bleiben an der Oberfläche kleben.

Köbi Gantenbein: Es ist bemerkenswert, mit welcher Neugier du immer wieder von Material und vom Handwerk sprichst und wie gerne du Baubegriffe brauchst. Der Kunsthistoriker Christof Kübler berichtet in

einem grossen Essay über deine Arbeit[5]: «Es lässt sich leicht erkennen, dass seine Arbeit nicht einfach Dokumentarcharakter anstrebt, wenngleich sein Vorgehen dokumentarisch-sachlicher Natur ist.»

Hans Danuser: Ich ging ohne grosse Vorkenntnis der Architektur und deren Darstellung in der Fotografie an dieses Projekt heran. Ich studierte die Pläne von Peter Zumthor, ich ging immer wieder zu den Bauten. Gewisse Parameter waren konzeptuell bewusst gesetzt, andere zeigten sich erst im Rückblick: Neu am Zyklus zu Sogn Benedetg war meine Fokussierung auf Nebenschauplätze. Im Zentrum von Bild III steht ein Zaun (Seiten 16-17). Bauern der angrenzenden Höfe haben ihn gebaut. Er begrenzt den Weg, der an der Kapelle vorbei zum Maiensäss führt. Bedingt durch das Wetter, suggeriert der Zaun auf dem Bild die Abgrenzung vor einem alpinen Abgrund. Natur und Architektur sind in der Fotografie gleichwertig gewichtet. Verstärkt wird dieser gleiche Wert über die Konzentration auf das gleiche Material, das Holz. Das war damals spektakulär und irritierend. Neu war ebenfalls, dass ich nicht den abgeschlossenen Bau abwartete, sondern Bauetappen

5 Christof Kübler, *Grenzverschiebung und Interaktion. Der Fotograf Hans Danuser, der Architekt Peter Zumthor und der Schriftsteller Reto Hänny*, in: *Georges-Bloch-Jahrbuch des Kunstgeschichtlichen Seminars der Universität Zürich*, 1995, und unter: *www.hansdanuser.ch*, Kapitel «Bibliographie 1995»

el, constructed from larch, spruce, and ash, and later the Therme Vals, made of granite, I was without a doubt able to carry out this reduction more radically than in any of my other photographic works on architecture.

Köbi Gantenbein: Part of this radicalness also entails a clear decision: why did you choose black-and-white for all these works?

Hans Danuser: To me black-and-white was the only way to photograph Zumthor's buildings. The reason for this is because his buildings are developed from the inside out — they manifest themselves as bodies. I think black-and-white or the light-dark technique brings out this corporality much better than color does. As soon as we're dealing with the representation of an architectural position with emphasis on the façade design, color again becomes the better choice. What is interesting is that when you take object surfaces and transfer these to the photographic image, the only way to make the building tangible is by using in the light-dark technique, i.e. in the spectrum of shades of gray from the lightest light to the darkest dark. As soon as you introduce color photography into the game, the porosity of the sur-

faces disappears and with it, the photo's depth gives way to nothing. There's no way around it, the viewer's eye gets stuck on the surface.

Köbi Gantenbein: Listening to you speak, I am amazed at how fascinated you are about building materials and their handling and how fond you are of construction terms. In a long essay, the art historian Christof Kübler says the following about your work[5]: "It is easy to see that his pictures do not strive for a merely documentary character, although his approach is of an objective, documentary nature."

5 Christof Kübler, *Grenzverschiebung und Interaktion. Der Fotograf Hans Danuser, der Architekt Peter Zumthor und der Schriftsteller Reto Hänny* [Shifting Boundaries and Interaction. Photographer Hans Danuser, the Architect Peter Zumthor, and the Author Reto Hänny], in: *Georges-Bloch-Jahrbuch des Kunstgeschichtlichen Seminars der Universität Zürich*, 1995, and under: *www.hansdanuser.ch*, chapter «Bibliographie 1995»

festgehalten und in die gültige Serie integriert habe. Der Betrachter hat den Eindruck, es sei auch heute noch so, wie das die Bilder II 1 und II 2 zeigen (Seiten 12-15), es ist aber anders.

Köbi Gantenbein: Als ich deine Bilder zu Sogn Benedetg zum ersten Mal sah, haben mich weniger die Abbildung der Oberflächen, des Innenraums, des Alpzauns oder der Landschaft gefesselt als der Nebel. Plötzlich sah ich keine Kapelle, sondern schöne Momente meiner Zeit als Hirtenbub in den Schulferien im Prättigau. Warum scheint bei dir keine Sonne?

Hans Danuser: In der Fotografie der Architektur schien bis Ende der 1980er-Jahre fast immer die Sonne, vielleicht war es manchmal ein wenig bedeckt. Aber es regnete nie und natürlich gab es keine vier Jahreszeiten. Eigentlich gab es gar kein Wetter. Die Architektur zeigte sich in der Fotografie in einem wetterlosen Zustand. Als ich die Kapelle Sogn Benedetg das erste Mal besuchte, hatte ich wie du Erinnerungen an meine Kindheit, wie ich jeweils auf einer Alp und in einem Maiensäss mithalf. Schon im Sommer konnte es diese Nebelschwaden geben, die den Boden berührten und die Landschaft in ein zauberhaftes Mysterium verwandelten, voller Geister und Geschichten. Es war mir klar, dass ich diese Kapelle von aussen nur unter diesen Bedingungen fotografieren konnte. Die Faszination des Nebels ist ja nicht nur die Feuchtigkeit oder die Akustik, die einem vermittelt, alles sei ganz nahe, sondern vor allem das diffuse Licht. Licht ist auch der Stoff, der schon in Peter Zumthors frühem Werk einen zentralen Platz einnimmt. Sein Umgang mit Licht hat mich lange beschäftigt. Im sechsteiligen Bildzyklus zu den Schutzbauten über den römischen Funden im Welschdörfli von Chur faszinierte mich die Leichtigkeit von Peter Zumthors Architektur in Kontrast zur Schwere der «ausgegrabenen Architektur», den Mauerresten der römischen Bauten. Ich habe dann eine Sequenz eingebaut, die im Bild einzig die römische Architektur zeigt. Die neue Architektur ist in jener Fotografie allein über die Lichtführung auf den historischen Bauten präsent.

Hans Danuser: I embarked on this project without any previous knowledge about architecture and its photographic representation. I studied Peter Zumthor's plans, I went to visit the buildings several times. Certain conceptual parameters were consciously set, others only became evident later: what was new about my series on Sogn Benedetg Chapel was my focus on secondary elements. At the center of photo III is a fence (pages 16-17). It was built by neighboring farmers and marks the path leading past the chapel to the spring pastures. The fog in the picture makes the fence seem like a boundary line at the edge of an alpine abyss. In the photo, nature and architecture are given the same value. This balance of value is reinforced by the concentration on their shared material: timber. At the time it was both spectacular and disturbing. Another new aspect was that I didn't wait for the building to be completed, but captured different stages of construction and integrated them into the final series. The viewer thinks the building still looks the way it did in photos II 1 and II 2 (pages 12-15), but of course it doesn't.

Köbi Gantenbein: When I first saw your pictures of Sogn Benedetg Chapel, it was not so much the image of the surface, the interior, the mountain fence, or the landscape that captivated me as it was the fog. Suddenly what I was seeing wasn't a chapel but wonderful memories of school holidays spent as a shepherd boy in Prättigau. Why doesn't the sun ever shine in your work?

Hans Danuser: In architectural photography the sun shone almost all the time until the late 1980s, maybe once in a while it was a little overcast. But it never rained, and of course there was no mention of the changing seasons. In fact, there was no weather at all. In the photograph, architecture always appeared in a weatherless setting. The first time I visited Sogn Benedetg Chapel I too was reminded of helping out as a child on a mountain farm and on a spring pasture. Even in the summer you would get this low-lying fog that transformed the landscape into a magical mystical world full of spirits and legends. I realized that I could only photograph the exterior of this chapel under these conditions. What is fascinating about fog isn't just the humidity or the acoustics that give you an impression of everything being very close, but above all it is the diffuse light. Light is also an element that played a

Köbi Gantenbein: Die drei Arbeiten für Peter Zumthor waren deine einzigen Auftragsarbeiten als Architekturfotograf. Warum hast du damit aufgehört?

Hans Danuser: Die Zusammenarbeit mit Zumthor war von Anfang an als Experiment angelegt und einmalig. Seine Anfänge in der Architektur stimmten mit meinem Interesse an der Fotografie überein und das Timing war ebenfalls richtig: Mein Bildzyklus IN VIVO war kurz zuvor fertig geworden und es reizte mich, eine andere Kunst, die Kunst der Architektur, kennenzulernen. Anschliessend beschäftigte ich mich mit meinem ersten Kunst-in-Architektur-Projekt, der Arbeit INSTITUTSBILDER – EINE SCHRIFT BILD INSTALLATION[6] an der Universität Zürich.

6 INSTITUTSBILDER – EINE SCHRIFT BILD INSTALLATION, Schriftbänder auf Wand, Fotografie auf Barytpapier, 1992

Köbi Gantenbein: Fotografie und Architektur entwickelten in den letzten zwanzig Jahren eine unerhörte Dynamik; die Fotografie hatte alle möglichen Interessen von Architekten, Bauherren, Verlagen, Museen und Bilderhändlern zu bedienen. Wie beurteilst du heute deine Skepsis gegenüber der Architekturfotografie?

Hans Danuser: Der Fotografie ist es gelungen, der Architektur in der medialen Öffentlichkeit den heutigen gesellschaftlichen Stellenwert zu verschaffen. Mich als Betrachter der Szene fasziniert an Architektur aber immer noch ihr Spiel, ihr Dialog mit dem Material und ihr Kampf mit oder gegen die Gesetze der Statik. Letztlich ist es also die gebaute Architektur ... oder dann eben doch ihre Darstellung im Modell, die mich berühren.

Dieses Gespräch beruht auf einem Diskurs von Hans Danuser und Köbi Gantenbein am 16. März 2007 anlässlich der Ausstellung *Gebaute Bilder – Architektur und Fotografie in Graubünden* im Gelben Haus, Flims. Besten Dank an Jürg Ragettli vom Bündner Heimatschutz, der den Abend organisierte und das Gespräch aufzeichnete, und an Christian Dettwiler, der mit Köbi Gantenbein zusammen die Ausstellung einrichtete.

central role in Peter Zumthor's early work. The way he handles light intrigued me for a long time. In the six-part series on the shelters for the Roman archaeological site in Welschdörfli in Chur, I was fascinated by the lightness of Peter Zumthor's architecture contrasted with the weight of the "excavated architecture," the Roman ruins. I incorporated a sequence of pictures of just the Roman architecture. The new architecture is discernible only in the light it throws on the ancient buildings.

Köbi Gantenbein: The three series you did for Peter Zumthor were your only commissioned works as an architectural photographer. Why didn't you continue?

Hans Danuser: From the beginning, my collaboration with Zumthor was intended as an experiment and one-time thing. His early stages in architecture corresponded with my interest in photography and the timing was right too: I had just completed my series IN VIVO and I was intrigued by the prospect of getting to know another form of art, the art of architecture. After this project I began work on my first art-in-architecture project INSTITUTSBILDER — EINE SCHRIFT BILD INSTALLATION[6] at the University of Zurich.

5 INSTITUTSBILDER – EINE SCHRIFT BILD INSTALLATION, stenciled texts on walls, photograph on baryt paper, 1992

Köbi Gantenbein: Over the past twenty years photography and architecture have generated an incredible dynamic force; photography has had to cater to the interests of everyone from architects to clients to publishing houses, museums, and art dealers. How do you assess your skeptical view of architectural photography today?

Hans Danuser: Photography has given architecture the social standing it enjoys in the media today. What I as an observer of the scene still find fascinating about architecture is its interaction, its dialogue with the material, and its battle with or against the laws of structural engineering. Ultimately, what touches me is built architecture ... or its representation as a model.

This interview is based on an interview with Hans Danuser conducted by Köbi Gantenbein on March 16, 2007, on the occasion of the exhibition *Built Pictures – Archiecture and Photography in Grisons* at Das Gelbe Haus in Flims. I would especially like to thank Jürg Ragettli of the Bündner Heimatschutz for organizing the evening and recording the interview and Christian Dettwiler, who together with Köbi Gantenbein designed the exhibition.

Therme Vals

Bilder von Hans Danuser

Therme Vals

Images by Hans Danuser

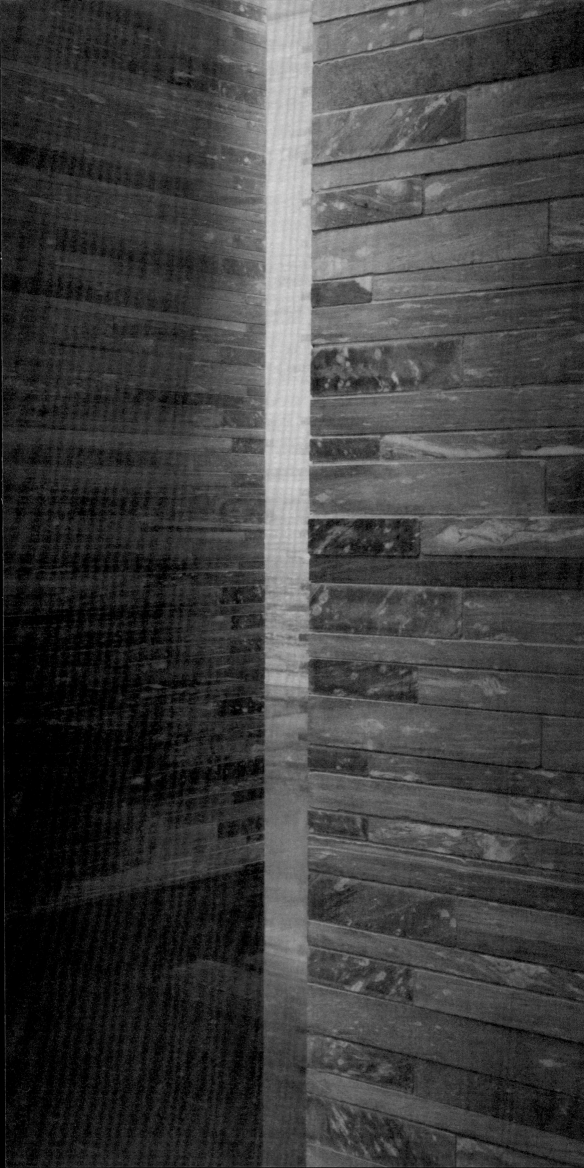

II

1 2

42

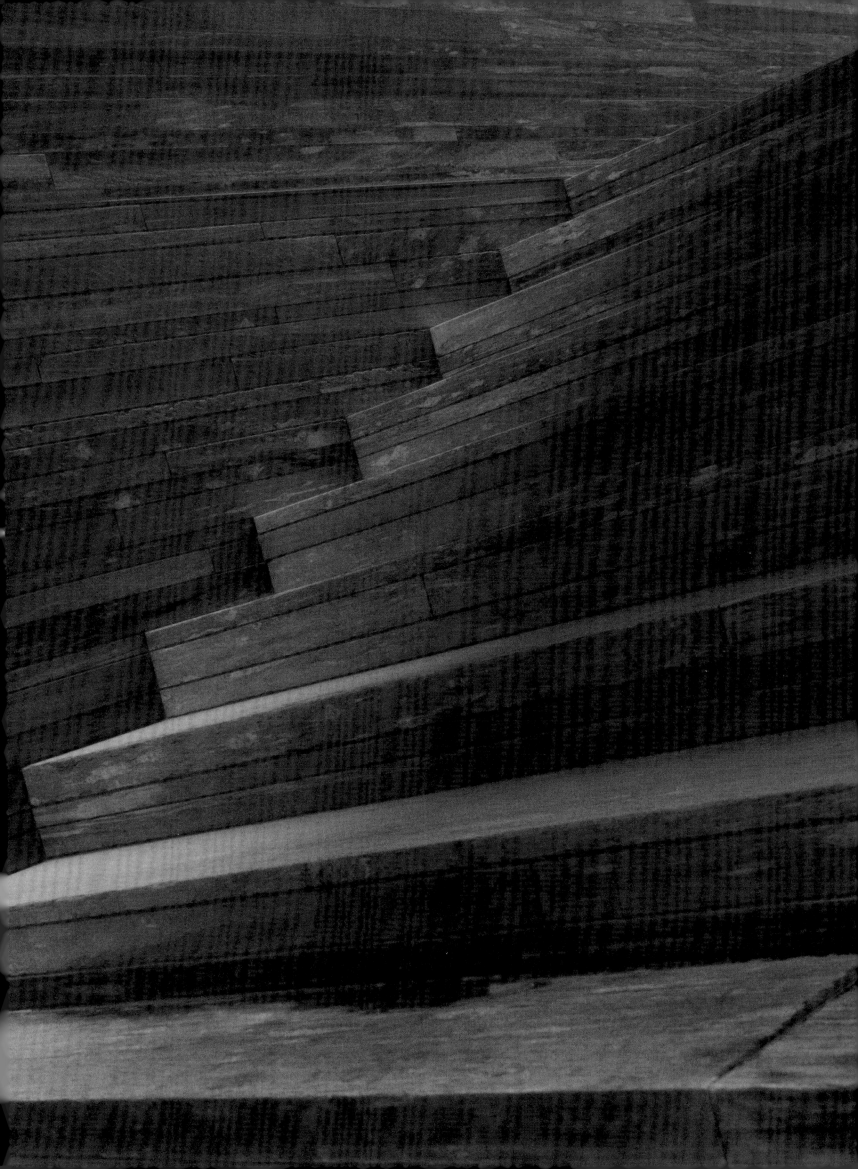

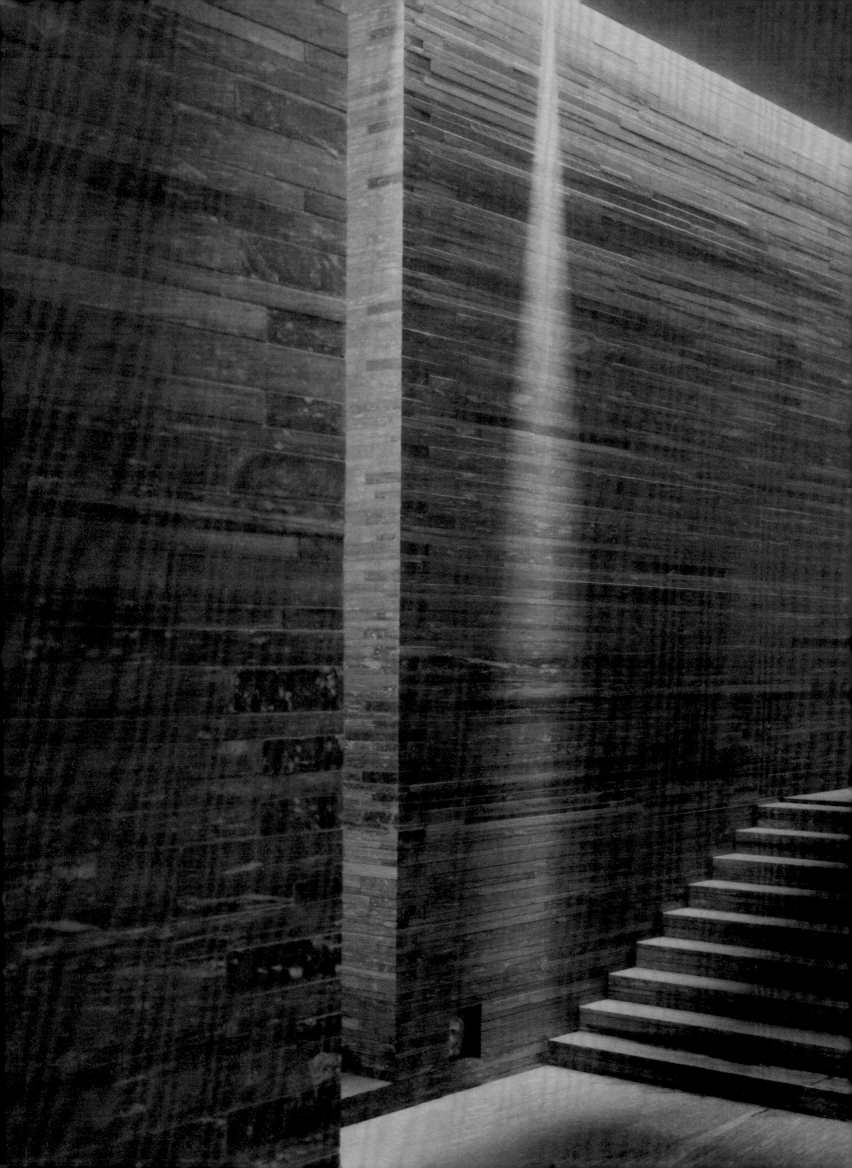

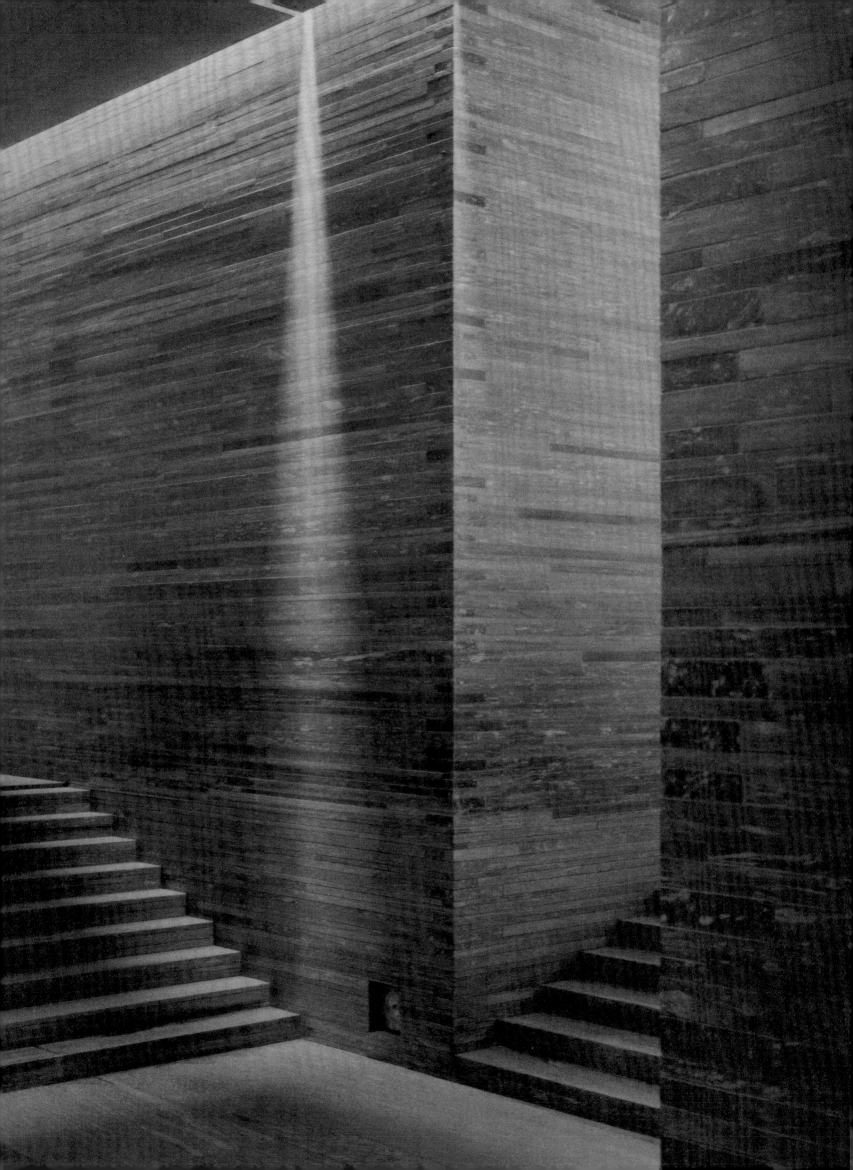

IV

1 2 3 4 <u>5</u>

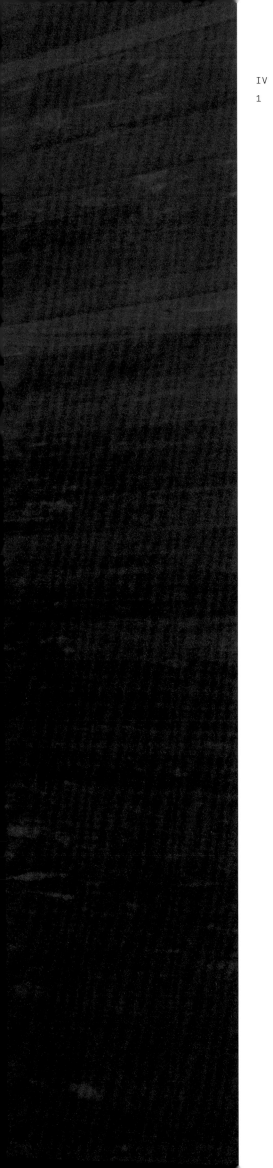

THERME VALS, Fotografien auf Barytpapier, 9-teilig, I, II 1–2,
III, IV 1–5, je auf Papierformat 50 x 40 cm, 1999

THERME VALS, photographs on baryt paper, 9 parts, I, II 1–2,
III, IV 1–5, format of each print 50 x 40 cm, 1999

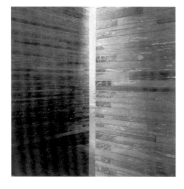

58

I

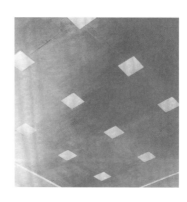 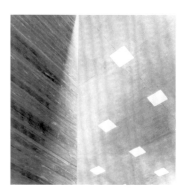

II

1

2

IV

1

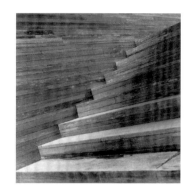

III

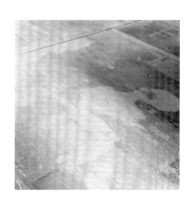

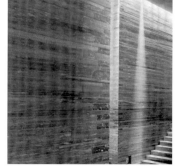

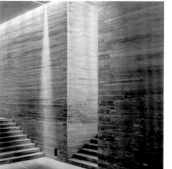

2

3

4

5

Die Visualisierung des Unsichtbaren

Hans Danuser und Peter Zumthor: Eine Revision. Von Philip Ursprung

Envisioning the Invisible

Hans Danuser and Peter Zumthor: A Revision. By Philip Ursprung

Mein Bild der Architektur von Peter Zumthor stand bis vor wenigen Jahren einigermassen fest. Ich hatte viel Respekt vor der Schönheit und atmosphärischen Wirkung seiner Bauten, der Konsequenz, mit der die verschiedenen Projekte auseinander hervorgingen, und dem im internationalen Vergleich gemächlichen Tempo, das sein Büro bestimmte. Aber ich war auch skeptisch gegenüber seiner Idee der Authentizität, der meiner Ansicht nach anachronistischen Auffassung der Natur sowie dem romantischen Impuls, der sein Werk durchdringt. Der Anspruch auf Selbstbezüglichkeit und Autonomie seiner Architektur liess mir als Historiker und Kritiker nur wenig Raum. Geprägt war dieses Bild durch den Besuch einiger seiner Bauten. Aber es war vor allem das Resultat der Fotografien, die Hans Danuser 1987 und 1988 von der Kapelle Sogn Benedetg gemacht hatte und über die ich Zumthors Werk zuerst wahrgenommen hatte. Namentlich jene Aufnahme, welche die sozusagen im Nebel aufgelöste Kapelle zeigt, hatte sich in meiner Imagination untrennbar mit dem Namen Zumthor verwoben. Vermittelt durch Danuser, fügte sich die neue Kapelle in eine jahrhundertelange Kette von trotzigen Burgruinen ein, welche die Hänge der Gegend prägen. Die Assoziation des Romantischen, des Weltflüchtigen, ja des Kulturpessimismus stellte sich zwangsläufig ein, wenn ich an Zumthors Architektur dachte. Ebenso stand mein Bild von Hans Danuser fest. Ich war seinem Werk 1989 in der Ausstellung *In Vivo* im Aargauer Kunsthaus, Aarau begegnet (Abb.).[1] Die körnigen Schwarzweissaufnahmen von Kühltürmen, Laboratorien und Seziertischen hatten mich gleichzeitig fasziniert und irritiert. Wie angesichts von Zumthors Architektur war ich skeptisch gegenüber einer künstlerischen Haltung, die mir im Neoexpressionismus der 1980er-Jahre verwurzelt schien und deren Antimodernismus und Pathos mir fremd waren. Zugleich liessen mich die Bilder nie ganz los. In meiner Erinnerung kehrten sie im Lauf der Jahre immer wieder. Sie wuchsen

1 Vgl. Hans Danuser, *In Vivo, 93 Fotografien*, Ausstellungskatalog Aargauer Kunsthaus Aarau, 1989

Up until a few years ago I was quite certain of my view of Peter Zumthor's architecture. I greatly respected the beauty and atmospheric effect of his designs, the logical progression from one project to the next, and — on the international stage — the comparatively moderate work-rate in his practice. But I was also skeptical about his notion of authenticity, about what seemed to me an anachronistic concept of Nature, and the ever-present Romantic undercurrent in his work. As an art historian and critic I was left little room for maneuver by the self-referentiality and autonomy of his architecture. My view of his work had been formed partly by my visits to some of his buildings, but much more importantly by the photographs Hans Danuser took of the Sogn Benedetg Chapel in 1987 and 1988; these were my first introduction to Zumthor's work. Most notably, a shot that shows the chapel seemingly dissolving in the mist had become inextricably connected in my imagination with the name Zumthor. Thanks to Danuser the new chapel took its place in a centuries-old sequence of defiant castle ruins that populate the hillsides in this area. Associations with Romantic ideals, other-worldliness — even cultural pessimism — inevitably arose whenever I thought of Zumthor's architecture. And my view of Hans Danuser was just as certain. I first encountered his work in 1989 in the exhibition *In Vivo* in the Aargauer Kunsthaus Aarau (fig.).[1] His grainy, black-and-white images of cooling towers, laboratories, and dissecting tables were both fascinating and discomfiting. In much the same way that I responded to Zumthor's architecture, skepticism colored my reaction to an artistic approach that seemed to me to be rooted in the Neo-Expressionism of the 1980s, and that favored an Anti-Modernism and pathos that were wholly alien to my way of thinking. And yet, I could never quite shake off the memory of those photographs. Over the years they kept coming back to me. They even grew, and

1 See Hans Danuser, *In Vivo, 93 Fotografien*, exh. cat. Aargauer Kunsthaus, Aarau, 1989.

sogar an, sodass ich sie mir stets grösser vor-
stellte als in den kleinen Formaten von 50 x 40 cm,
die in Wirklichkeit damals in Aarau gezeigt wor-
den waren.

Dann besuchte ich im Frühling 2004 den Weiler Sogn
Benedetg oberhalb Sumvitg. Schlagartig musste
ich beide Bilder, sowohl dasjenige von Zumthor als
auch dasjenige von Danuser, revidieren. Anstelle
eines schwermütigen Baus, der in der Abgeschieden-
heit der Alpen mit der Natur verschwimmt, stand
ich vor einem der elegantesten und fragilsten Ge-
bäude, die ich je gesehen hatte. Seit der Begeg-
nung mit der Bibliothek Eberswalde von Herzog & de
Meuron hatte ich kein so eindrückliches Erlebnis
angesichts von neuer Architektur gehabt. Alles kam
mir zeitgemäss vor, so als ob die Kapelle gerade
eben gebaut worden wäre und nicht vor fast zwanzig
Jahren. Der Bau, so meine Wahrnehmung, bestand
ausschliesslich aus Oberflächen, die sich überein-
anderlegten. Raum im herkömmlichen Sinne, das
heisst, als dreidimensional erfahrbare körperliche

Entität, kam gar nicht vor. Fenster, welche den
Übergang zwischen innen und aussen artikulierten –
und ein Indiz für die Vorstellung einer räum-
lichen Kontinuität wären –, gab es nicht. Statt-
dessen war das Dach ein wenig abgehoben, um Licht
einzulassen. Und die Wand, beziehungsweise die
äusserste, mit Schindeln überzogene Schicht, die
sich wie eine textile Membran um den Baukörper
zog, war gerade so weit aufgespreizt, dass sich ei-
ne Öffnung anbot, die aber wiederum kaum als Tür
bezeichnet werden konnte. Zudem war der Bau alles
andere als erdverbunden. Im Gegenteil, die weni-
gen Stufen vor dem Eingang schienen vor dem Kontakt
mit der Kapelle zu zögern, als ob der direkte

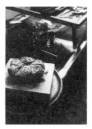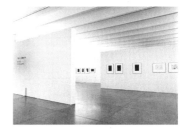

Ausstellungspublikation Hans Danuser, *Drei Fotoserien*, Dop-
pelseite mit Bildern aus IN VIVO, Serie *Medizin I*, Bild III 5
(*Hirn*), Bündner Kunstmuseum, 1985

Exhibition publication Hans Danuser, *Drei Fotoserien*,
double page with pictures from IN VIVO, the series *Medizin I*,
no. III 5 (*Hirn*), Bündner Kunstmuseum, 1985

Ausstellungssituation von *In Vivo* (1980–1989) im Aargauer
Kunsthaus, Aarau, 1989

View of the exhibition *In Vivo* (1980–1989) in Aargauer Kunst-
haus, Aarau, 1989

whenever I thought of them they were always larger
than the small-format photographs — 50 x 40 cm —
that had actually been shown in Aarau.

Then in spring 2004 I went to see the hamlet of
Sogn Benedetg, up above Sumvitg. And I immediately
had to revise the images in my head, my views
of Zumthor and Danuser. Instead of finding a deso-
late edifice tucked away in the Alps, merging
with the landscape, I came face to face with one
of the most elegant, fragile structures I had
ever seen. Not since my first sight of Herzog & de
Meuron's Eberswalde Library had any new archi-
tecture made such a deep impression on me. Every-
thing about it seemed to be of our own time,
as though this chapel had been built only yester-
day — not, as it was, almost twenty years ago.
The building itself, or so it seemed to me, con-
sisted exclusively of layered surfaces. It ap-
peared to have nothing to do with space in the
usual sense, that's to say, as a tangible, three-
dimensional entity. Nor were there any windows,
marking a transition between exterior and inte-

rior — which would have served as indicators of
spatial continuity of some kind. Instead the roof
was marginally raised to let light in. And the
wall, that is, the outermost layer, faced with
shingles — that was drawn around the structure like
a textile membrane — was splayed open just far
enough to create an opening, although hardly one
that could be described as a door. Added to which,
this structure was anything but earthbound. On
the contrary, the few steps leading up to the
entrance seemed to shy away from actually touching
the chapel, as though a direct connection be-
tween the ground and the building were impossible.
The topography of the Alpine landscape and the
topology of the architecture were at odds with
each other, discontinuous.

Übergang zwischen dem Terrain und dem Gebäude unmöglich wäre. Die Topografie der alpinen Landschaft und die Topologie der Architektur waren unvereinbar, diskontinuierlich.

Zumthors Kapelle nahm vieles vorweg, was in der architektonischen Diskussion der letzten Jahre verhandelt wurde. Die topologischen Entwürfe von Architekten wie Ben van Berkel oder Foreign Office Architects aus den späten 1990er-Jahren, die um das Thema des Möbiusbandes kreisen, wirkten im Vergleich zu Zumthors ein Jahrzehnt früherer Lösung wie Illustrationen zu einem theoretischen Programm. Und auch das Wahrzeichen der Schweizerischen Landesausstellung Expo.02, Diller + Scofidios' *Blur Building*, das ich damals als bahnbrechende Auseinandersetzung mit der atmosphärischen Wirkung wertete, schien der Rhetorik der eigenen Urheber plötzlich hinterherzuhinken. Zudem verwies Zumthors Kapelle nicht, wie ich befürchtet hatte, nur auf sich selber. Vielmehr veränderte sie die Art, wie ich die Umgebung wahrnahm, und versetzte sozusagen das ganze Tal in Bewegung. Es ging nicht um Autonomie und Isolation, sondern im Gegenteil um Assoziation und Präzision. Der Bau schärfte meinen Blick für die Zusammenhänge dieser Gegend, und er artikulierte die Energie, die hier floss. Energie nicht im Sinne von esoterischen Kraftlinien, sondern von institutionellen Zusammenhängen, welche die katholische Kirche in diesem Teil des Rheintals mit dem einst mächtigen Kloster Disentis und so mit dem globalen Katholizismus verbindet. Energie aber auch als Stromproduktion, von der die Region abhängt. Ich stand nicht nur in einer alpinen Landschaft, sondern auch in einer Industrielandschaft. Ich spürte keinen Widerspruch zum Urbanen. Zumthors Architektur machte deutlich, dass es gar keine Alternative zum Urbanen geben konnte, indem sie vom Drama einer Landschaft erzählte, die ganz und gar vom Menschen gemacht ist. Ich war nicht in der Peripherie, sondern mitten in einem Netz, dessen Fäden sich ausspannten nach Berlin, New York und Tokio.

Zumthor's chapel anticipated much of the architectural debate of recent years. Even so, the topological designs inspired by the Möbius strip and produced by architects such as Ben van Berkel or Foreign Office Architects looked — in comparison to Zumthor's much earlier solutions — like illustrations for a theoretical treatise. And even the landmark of the Swiss Expo.02, Diller + Scofidios' *Blur Building*, which I regarded at the time as a ground-breaking exploration of atmospheric effects, now seems to have been merely limping along behind the rhetoric of its own makers. Moreover Zumthor's chapel was not, as I had feared, simply self-referential. On the contrary it changed the way that I perceived the surroundings and seemed to imbue the whole valley with a sense of movement. It was not about autonomy and isolation. Far from it — this design was about associations and precision. The built structure sharpened my eye for the terrain as a whole and it articulated the energy flowing through this region; not in the sense of esoteric energy lines, but of the institutional connections that still link the Catholic Church in this part of the Rhine valley with the once mighty Abbey Disentis which in turn connects with the global Catholic community. And also in the sense of the generation of power that is crucial to this region. This Alpine landscape was also an industrial landscape. But to me there seemed to be no contradiction with urbanism. Zumthor's architecture made it very clear that there could be no alternative to urbanism for it told of a landscape that was entirely made by human hand. I was not on the periphery but right at the heart of a network that extended to Berlin, New York, and Tokyo.

The Iconic Turn and the Perception of Architecture

The point of relating this experience was not to make much of my own subjective reaction. For my revised view is a consequence of the general shift in a notion that pervaded architecture in the 1980s but has only recently been satisfactorily described. I am referring here to the transition from the notion of architecture as a system of signs, as a text or language that can be 'read,'

Der Iconic Turn und die Wahrnehmung
der Architektur

Ich erwähne diese Erfahrung nicht, um meine subjektive Reaktion ins Spiel zu bringen. Vielmehr ist meine Revision eine Folge der allgemeinen Verschiebung der Auffassung, welche in den 1980er-Jahren in der Architektur vorherrschte, die aber erst seit kurzem begrifflich beschrieben werden kann. Es handelt sich um den Übergang der Auffassung von Architektur als Zeichensystem, als Text oder Sprache, die ‹gelesen› werden kann, hin zur Auffassung von Architektur als Bild, dessen Wirkung ‹erfahren› wird. Bei diesem Übergang, Teil eines kulturgeschichtlichen Trends, der heute allgemein als «Pictorial Turn» oder «Iconic Turn» bezeichnet wird, spielte die Fotografie eine Hauptrolle. Und die Begegnung zwischen Danuser und Zumthor markiert einen entscheidenden Punkt.[2]

Die Revision des Bildes von Zumthors Architektur, die sich durch die Begegnung mit dem Gebäude aufdrängte, war Anlass, auch die Fotografie von Danuser genauer zu betrachten. Erst jetzt wurde

[2] Vgl. Ilka & Andreas Ruby, Philip Ursprung, *Images: A Picture Book of Architecture*, München, Prestel, 2004

mir bewusst, dass es sich ja nicht um eine einzelne Fotografie handelte, sondern um eine Abfolge, die nur in meiner Erinnerung zu einem Bild geronnen war. Danuser hatte im Auftrag von Zumthor die eben fertig gestellte, im September 1988 geweihte Kapelle 1987 und 1988 mit einer Mittelformat-Kamera und Schwarzweiss-Film fotografiert. Das Resultat war eine Serie von sechs quadratischen Fotografien. Sie wurden zuerst, zusammen mit Aufnahmen von Zumthors Schutzbauten für römische Ruinen in Chur und dem Atelierbau in Haldenstein, in der Ausstellung *Partituren und Bilder: Architektonische Arbeiten aus dem Atelier Peter Zumthor 1985–1988* in der Architekturgalerie Luzern und der Architekturgalerie Graz 1988 gezeigt. Danach wurden sie in den Zeitschriften *Du*, *Ottagono* und *Domus* publiziert.[3]

[3] Vgl. «Domestico/Antidomestico 2», in: *Ottagono 97*, 1990; «Fotoessay III. Hans Danuser», in: *Du, Die Zeitschrift für Kunst und Kultur*, «Pendenzen: Neuere Architektur in der Deutschen Schweiz», Heft 5, 1992.

to that of architecture as an image that affects the viewer and is 'experienced.' Central to this transition — part of a cultural trend that is today generally referred to as the "pictorial turn" or "iconic turn" — is the role of photography. And in this process the meeting between Danuser and Zumthor was to be highly significant.[2]

This revision of my view of Zumthor's architecture — prompted by my encounter with the chapel — also gave me the urge to take a closer look at Danuser's photograph. And it was only now that it dawned on me that of course this photograph did not exist in isolation; it is part of a series that in my mind had run together into a single image. In response to a commission from Zumthor, in 1987 and 1988 Danuser had taken these black-and-white

[2] See Ilka & Andreas Ruby, Philip Ursprung, *Images: A Picture Book of Architecture*, Munich: Prestel, 2004

photographs (with a medium-format camera) of the newly constructed chapel, which was inaugurated in September 1988. The result was a series of six square, black-and-white photographs. They were first shown in the exhibition *Partituren und Bilder: Architektonische Arbeiten aus dem Atelier Peter Zumthor 1985–1988* — which also contained pictures of Zumthor's Shelters for the Roman archeological site in Chur and his studio in Haldenstein — presented in the Architekturgalerie Luzern and the Architekturgalerie Graz in 1988. They were subsequently also published in the magazines *Du*, *Ottagono* and *Domus*.[3]
Danuser had photographed different aspects of the interior and the exterior, as though a single image could not do the chapel justice. So his interest was not, as I had imagined, simply in evoking things irrational and capturing the atmosphere, but rather in addressing a much more fun-

[3] See "Domestico/Antidomestico 2," in *Ottagono 97*, 1990; "Fotoessay III. Hans Danuser", in: *Du, Die Zeitschrift für Kunst und Kultur*, "Pendenzen: Neuere Architektur in der Deutschen Schweiz", no. 5, 1992

Danuser hatte verschiedene Aspekte des Inneren und des Äusseren aufgenommen, als ob ein einzelnes Bild dem Bau gar nicht gerecht werden könnte. Sein Thema war also weniger, wie ich geglaubt hatte, die Evokation des Irrationalen und die Wiedergabe von Stimmungen als ein viel grundsätzlicheres Problem der Kunst, nämlich das Unsichtbare sichtbar zu machen. Den Anfang macht eine Aufnahme der Kapelle und ihrer Umgebung (Abb.). Danuser verzichtete darauf, die spektakuläre Aussicht auf die Surselva abzubilden. Die Verbindung von Landschaft und Gebäude in der traditionellen Architekturfotografie war derart konventionell geworden, dass beide einander quasi ausblendeten. Indem er sich bewusst mit dem Rücken zur Aussicht stellte,

entkam er dem Klischee ‹Graubünden› – und prägte zugleich jene für die Identität der Bündner Architektur zentrale Fokussierung auf Oberflächen und Texturen der spezifischen Materialien dieser Gegend.

Ein weiterer Unterschied zum Bild, das ich mir gemacht hatte, war die Tatsache, dass die Kapelle auf den Fotografien sehr hell ist. Die Schindelmembran, welche den Bau wie ein eng anliegendes Geflecht überzieht, ist noch nicht durch das Sonnenlicht dunkel geworden. Der Bau zeigt noch keine Spuren des Laufes der Zeit. Und vor allem ist er nicht von Nebelschwaden überzogen, wie ich gemeint hatte. Vielmehr verdeckt der Nebel das, was über ihm liegt. Die Wirkung ist also nicht, wie beispielsweise in den Gemälden der Kirchen von Caspar David Friedrich, erhaben, also eine Verschmelzung des Irdischen mit einem Jenseitigen, sondern vielmehr desublimierend, ernüchternd. Die Kapelle steht roh in der Umgebung, ein Fremdkörper, der brutal eingeschlagen hat, so wie die Felsbrocken, die von der zerstörerischen Gewalt der

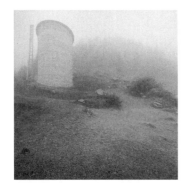

CAPLUTTA SOGN BENEDETG, SUMVITG, Bild I, Fotografien auf Barytpapier, 6-teilig, I, II 1–2, III, IV 1–2, je auf Papierformat 50 x 40 cm, 1988

CAPLUTTA SOGN BENEDETG, SUMVITG, no. I, photographs on Baryt paper, 6 parts, I, II 1–2, III, IV 1–2, paper format 50 x 40 cm, 1988

damental issue in art, that is to say, making the invisible visible. The series begins with a shot of the chapel and its surroundings (fig.). Danuser passed up the chance to photograph the spectacular view out over the Surselva. In traditional architectural photography the connection between landscapes and buildings had become so conventional that in effect each would cancel the other out. By deliberately turning his back on the view, he managed to sidestep the 'Grisons' cliché — and in so doing drew attention to the focus on the surfaces and textures of the specific materials from this area that is so characteristic of this region's architecture.

Another factor that was at odds with the picture I had created in my mind's eye was that the chapel in these photographs is very pale. The shingle membrane, that clads the structure like closely fitting webbing, has not yet darkened in the sunlight. As yet the chapel shows no signs of the passage of time, and above all it is not shrouded in banks of mist, as I had thought. In reality the mist conceals what is beyond it. Consequently it is not, as in Caspar David Friedrich's paintings of isolated churches, for instance, as though this world were indistinguishable from the next, it is distinctly unsublime, sobering. The chapel looms large in its setting, a foreign body that has landed there with the same brutality as the sharp-edged rocks that bespeak the destructive power of Nature. At the time many would still vividly have remembered the terrifying powder avalanche of February 1984 that had destroyed the original medieval chapel just two hundred meters away. And the bell tower is equally unsettling.

Natur erzählen. Damals war die Erinnerung an die verheerende Staublawine noch wach, welche im Februar 1984 gut 200 Meter davon entfernt den mittelalterlichen Vorgängerbau zerstört hatte. So gesehen, wirkt auch der Glockenturm befremdlich. Ich hatte ihn mir wie einen Baum vorgestellt. Aber jetzt mutete er an wie ein Mast der Stromleitungen und Bergbahnen, welche die Gegend durchziehen, ein Element, das sowohl verbindet wie auch durchtrennt. Kurz, das romantische Bild der Architektur, welche in der Natur aufgeht, das ich, vermeintlich durch Danusers Fotografien inspiriert, in mir trug, traf weder auf Zumthors Architektur noch auf Danusers Interpretation zu.

Mein neuer Blick auf Danusers Fotografie vermittelte mir den Eindruck, dass sie den Konnex zwischen Gebäude und Landschaft nicht als ästhetische Verbindung zeigt, sondern etwas sichtbar machte, was gewöhnlich übersehen wird, nämlich den ökonomischen Zusammenhang. So ist die Aufnahme, welche den an die Kapelle angrenzenden Zaun zeigt (CAPLUTTA SOGN BENEDETG, SUMVITG, III, Seiten 16-17) nur auf den ersten Blick ‹malerisch›. Interessanter als die formale Wirkung ist, dass sie von dem für die Bergregion typischen Kostendruck und den pragmatischen Antworten darauf zeugt. Indem Danuser neben dem Zaun einen Ausschnitt des Neubaus zeigt und dessen Betonsockel sichtbar belässt, verhindert er jede nostalgische Evokation einer vermeintlich heilen, vorindustriellen Welt. Er rückt stattdessen den Aspekt der Arbeit ins Licht, sei diese nun industriell organisiert oder vorindustriell. Er zeigt dem Betrachter, wie diese Artefakte, der Zaun ebenso wie die Kapelle, hergestellt wurden. Die eingerammten, unbearbeiteten Äste, zwischen die die billigen Rindenstücke aus der Herstellung von Brettern eingefügt wurden, sind ebenso Abfallprodukte aus dem Holzgewerbe wie die Schindeln, welche die Aussenwand der Kapelle vor Verwitterung schützen. Indem Danuser quasi mit den Augen der Bauern, Zimmerleute und Schreiner auf die Kapelle

67

In my memory it was something like a tree. But in reality it looks more like a pylon for the cables and mountain railways that criss-cross this area, an element that both connects and divides. In short, my Romantic image of architecture that has become one with Nature — presumably inspired by Danuser's photographs — was right out of kilter with both Zumthor's architecture and Danuser's interpretation.

My new view of Danuser's photography now gave me the impression that it is not about the aesthetic connection between a building and the landscape but that it brings to light something that is generally overlooked, that is to say, the economic connection. Witness the shot that shows the fence almost touching the chapel (CAPLUTTA SOGN BENEDETG, SUMVITG, III, pages 16-17) which is more than just 'picturesque' — although this may be one's first impression. Much more interesting than its formal effect is what it tells us about the financial pressures that are ever-present in this mountainous region and the pragmatic solutions that the locals come up with. By including a section of the new chapel with its visible concrete substructure in this image, Danuser avoids any hint of the nostalgic evocation of a supposedly intact, pre-industrial world. He shows the viewer how these artifacts, the fence and the chapel, were made. The roughly worked branches rammed into the ground supporting the cheap bark offcuts from a sawmill are just as much by-products of the timber trade as are the shingles that protect the exterior of the chapel from the elements. By as it were viewing the chapel with the eye of the farmer, the joiner, and the carpenter, he illuminates the work process — and with just a few photographs tells us more about Zumthor's architectural methods than any text that happens to mention his training as a cabinet maker. A similarly subtle insight into the chapel's making is to be had from the details of the floor before and after the benches were installed (CAPLUTTA SOGN BENEDETG, SUMVITG, II 1-2, pages 12-15). Although the boards are small — and hence cheap — the variety and ornamental nature of the

blickt, macht er den Arbeitsprozess deutlich – und sagt gleichzeitig mit einigen Fotografien mehr über Zumthors Methode als Architekt aus als jeder Text, der dessen Ausbildung zum Schreiner beiläufig erwähnt. Einen ähnlich subtilen Blick auf die Herstellung geben auch die Details des Bodens bevor und nachdem die Bänke eingebaut sind (CAPLUTTA SOGN BENEDETG, SUMVITG, II 1–2, Seiten 12–15). Sie zeigen, dass zwar kleine, also preiswerte Bretter eingesetzt wurden, die aber durch ihre ornamentale Maserung und Variation das Interieur formal aufwerten. Eine Detailaufnahme (CAPLUTTA SOGN BENEDETG, SUMVITG, IV 1, Seiten 18–19) wirkt auf den ersten Blick fast wie ein technischer Kommentar zur Konstruktion, die zeigt, wie die tragenden Balken mit der Hülle verbunden sind. Aber sie ist für mich vor allem aus der Perspektive der Raumtheorie brisant. Sie belegt, dass es für Zumthor gar nicht möglich

ist, den Raum anders zu denken denn als Resultat von textilen Begrenzungen; wie ein Zelt, beziehungsweise wie eine Bühne, die durch Vorhänge und Kulissen – lauter Oberflächen – ihre Wirkung entfaltet.

Danuser änderte mit den Aufnahmen von Sogn Benedetg die Konvention der Architekturfotografie radikal. Statt für neutrale Dokumentation interessierte er sich für eine persönliche Interpretation. Und anstatt das Phänomen auf eine Aufnahme zu reduzieren, zerlegte er den Bau quasi in Einzelteile, wie einen kurzen Film, der den Gegenstand in Sequenzen aufgegliedert und aus unterschiedlichen Perspektiven zeigt – heute würde man dies «performativ» nennen. Diese Fragmente bieten den Betrachtern die Möglichkeit, den Bau in der Fantasie zu rekonstruieren. Danuser hat damit die Rezeption von Zumthors Architektur geprägt. So wie jeder, der einmal die Fotografie von Hans Namuth gesehen hat, die Jackson Pollock beim Malen in seinem Atelier zeigt, ein Gemälde Pollocks zwangsläufig mit dem Bild seiner Herstellung in Verbindung bringt, so ist auch Danusers Bild mit dem Werk von Zumthor seither irreversibel verschmolzen.

wood grain greatly enhances the chapel's interior. A shot of another detail (CAPLUTTA SOGN BENEDETG, SUMVITG, IV 1, pages 18–19) looks at first sight almost like a technical commentary on the construction, showing how the load-bearing uprights are connected to the shell. But for me it is highly significant in terms of spatial theory. It shows that for Zumthor it is just not possible to think of a space other than as being defined by a sequence of textile planes, like a tent, or a stage that achieves its effect by means of curtains and sets — all flat surfaces.

With his shots of Sogn Benedetg, Danuser radically affected the conventions of architectural photography. Instead of producing a neutral documentation he pursued his own personal interpretation. And instead of reducing the phenomenon of the chapel to a single shot, he in effect divided the building up into individual components, as though for a short film that dissects its subject matter into sequences showing it from different perspectives — these days this approach would be described as "performative." These fragments allow viewers to reconstruct the building in their own

imagination. And in so doing Danuser colored the reception of Zumthor's architecture. In the same sense that anyone who has ever seen Hans Namuth's photograph of Jackson Pollock at work in his studio, so, too, will Danuser's photographs forever be linked with Zumthor's work.

How did these two make contact? In the early 1980s Danuser was already working his way from photography as an applied art to art-photography. In 1984 he was the first photographer to be awarded an atelier grant by the City of Zurich that allowed him to go to New York. In 1985 he exhibited three series of photographs in Kunstmuseum Chur. Zumthor saw this exhibition and later decided to commission Danuser to take photographs of Sogn Benedetg. The two agreed that Danuser would have a free hand. And it was this encounter between Hans Danu-

Wie kam es zu dieser Zusammenarbeit? Danuser beweg-te sich Anfang der 1980er-Jahre von der Fotogra-fie als angewandter Kunst hin zur künstlerischen Fotografie. 1984 erhielt er als erster Fotograf ein Atelierstipendium der Stadt Zürich in New York. 1985 stellte er im Kunstmuseum Chur drei Fotoseri-en aus. Zumthor sah die Ausstellung und entschied sich später, Danuser mit den Aufnahmen von Sogn Benedetg zu beauftragen. Als Spielregel wurde ver-einbart, dass Danuser freie Hand hätte. Das Zu-sammentreffen der Fotografie von Hans Danuser mit der Architektur von Zumthor läutete wie gesagt eine Wende der Architekturdarstellung ein, welche weit über den Rahmen der Schweizer Architektur hinaus Folgen hatte.[4] Es war eine Phase von etwas mehr als einem Jahrzehnt, in der sowohl die Foto-grafie als auch die Architektur ihr Terrain neu definierten und wo die Architekten den Fotografen grösste Freiheit zugestanden. Zur selben Zeit, als Danusers Fotografien in Luzern zu sehen waren, umkreisten Jacques Herzog und Pierre de Meuron in ihrer Ausstellung *Architektur Denkform* im Ar-chitekturmuseum Basel das Problem der angemessenen Darstellung von Architektur, indem sie die moder-nistischen Scheiben des Museums ganz mit transpa-renten Fotografien ihrer Bauten bedeckten. Aber erst drei Jahre nach Zumthor wählten auch sie den Weg über die künstlerische Fotografie und stell-ten anlässlich der Architekturbiennale Venedig 1991 Fotografien ihrer Bauten verschiedener Künstler aus.[5] Seit den 1990er-Jahren hat sich vor allem Thomas Ruff sowie einmal Jeff Wall mit ihrem Werk auseinandergesetzt.[6]

4 Vgl. Christof Kübler, «Grenzverschiebung und Interaktion: Der Fotograf Hans Danuser, der Architekt Peter Zumthor und der Schriftsteller Reto Hänny», in: *Georges-Bloch-Jahr-buch des Kunstgeschichtlichen Seminars der Universität Zürich*, 1995, S. 163–183

5 *Architektur von Herzog & de Meuron*, fotografiert von Margherita Krischanitz, Balthasar Burkhard, Hannah Villiger und Thomas Ruff, mit einem Text von Theodora Vischer, hg. vom Bundesamt für Kultur, Baden, Lars Müller, 1991

6 Vgl. *Pictures of Architecture, Architecture of Pictures*, Conversation between Jacques Herzog and Jeff Wall, moderated by Philip Ursprung, Wien, Springer, 2004

ser's photography and Peter Zumthor's architec-ture that was to instigate change in the portrayal of architecture both at home in Switzerland and far beyond the realms of Swiss architecture.[4] Over the next decade or so, both photography and ar-chitecture set about redefining their territory, during which time the architects allowed the pho-tographers the greatest possible freedom. At the same time that Danuser's photographs were on view in Lucerne, the Architekturmuseum Basel was show-ing the exhibition *Architektur Denkform* by Jacques Herzog and Pierre de Meuron in which they con-fronted the problem of the representation of archi-tecture by completely covering the modernist window-panes of the museum with transparent photo-graphs of their own buildings. It was not until three years after Zumthor had chosen the art-pho-tography route that they followed suit at the Architecture Biennale in Venice by showing photo-graphs of their building shot by a number of different artists.[5] Since the 1990s Thomas Ruff has been mainly involved with their work; Jeff Wall was involved just once.[6]

This period of just over ten years has a particu-lar place in the long history of the relationship between photography and architecture, and has much in common with the late 1920s, when Mies van der Rohe's Barcelona Pavilion for the World Ex-hibition of 1929 was famously photographed. Disman-tled again after the exhibition, it is as though the Pavilion had been built just for the camera and

4 See Christof Kübler, "Grenzverschiebung und Interaktion: Der Fotograf Hans Danuser, der Architekt Peter Zumthor und der Schriftsteller Reto Hänny", in: *Georges-Bloch-Jahrbuch des Kunstgeschichtlichen Seminars der Universität Zürich*, 1995, pp. 163–183

5 *Architektur von Herzog & de Meuron*, photographed by Mar-gherita Krischanitz, Balthasar Burkhard, Hannah Villiger, and Thomas Ruff, with a text by Theodora Vischer, ed. by Bundes-amt für Kultur, Baden: Lars Müller, 1991

6 See *Pictures of Architecture, Architecture of Pictures*, Conversation between Jacques Herzog and Jeff Wall, moderated by Philip Ursprung, Vienna: Springer, 2004

Diese Phase nimmt innerhalb der langen Geschichte des Verhältnisses zwischen Fotografie und Architektur eine besondere Stellung ein und ist allenfalls mit der Zeit der späten 1920er-Jahre vergleichbar. Berühmt sind die Aufnahmen von Mies van der Rohes Barcelona-Pavillon für die Weltausstellung 1929, der ja, nach der Ausstellung abgebrochen, sozusagen für die Kamera gebaut und erst durch die Fotografie zu einer Ikone der modernen Architektur geworden war. Mit der Etablierung der «Signature Architecture» um 2000 ging die Zeit der fruchtbaren Begegnung zwischen Architektur und Kunst wieder zu Ende. Viele Künstler haben sich zwar des Gegenstands Architektur angenommen. Aber die Architekturfotografie steht, mit wenigen Ausnahmen wie Hélène Binet, wieder fest im Dienst der

Architekten als Mittel der Propaganda, nicht der kritischen Auseinandersetzung. Als adäquates Medium der Darstellung von Architektur hat sich inzwischen Video durchgesetzt. Auch dies hängt mit Danusers sequenziellem Vorgehen Ende der 1980er-Jahre zusammen.

Er entwickelte den Ansatz denn auch weiter, als er sich mit der Therme Vals befasste. Zumthor hatte 1986 den Wettbewerb gewonnen und konnte den Bau 1996 eröffnen. Der Komponist und Perkussionist Fritz Hauser beauftragte Danuser, einen Bildessay für das Booklet der 2000 erschienenen CD *Steinschlag* mit Klangsteinmusik in Zumthors Bau anzufertigen (Abb.). Danuser realisierte die Aufnahmen 1999 und ging vergleichbar vor wie bei Sogn Benedetg. Er arbeitete wieder mit schwarzweissem Mittelformat-Film. Und er zerlegte das Interieur wiederum in einzelne Sequenzen. Die Aufnahmen entstanden bewusst in einem Moment, als sich kein Wasser in der Therme befand und somit das Innere nicht vom Spiel der Lichtreflexe geprägt war. Zu-

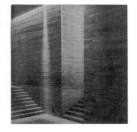

Hans Danuser, Peter Zumthor, Fritz Hauser, *Sounding Stones – Therme Vals*, CD-Booklet, Doppelseite mit Bild III 5, 2000

Hans Danuser, Peter Zumthor, Fritz Hauser, *Sounding Stones — Therme Vals*, CD booklet, double page, no. III 5, 2000

it was only through photography that it became an icon of modern architecture. After 2000, the onset of "signature architecture" marked the end of this period during which architecture and art converged so productively. Although many artists have actively engaged with architecture, these days — aside from notable exceptions such as Hélène Binet — architectural photography is once again firmly at the beck and call of the architects as a propaganda tool, and not as an aid to critical reflection. In the meantime the medium of video has established itself as a useful means to represent architecture. Once again, there is a connection here with the sequential method that Danuser developed in the late 1980s.

He took this approach a stage further when he turned his attention to the thermal spring in Vals. In 1986 Zumthor won the competition for this project and the new premises were opened in 1996. The composer and percussionist Fritz Hauser commissioned a photo-essay from Danuser, to be published 2000 in the booklet for the CD *Steinschlag* with sounding-stone music performed in Zumthor's new building (fig.). Danuser shot this series of photographs in 1999, proceeding much as he had done earlier at Sogn Benedetg. Once again he used a medium-format film in black and white. And again he divided the interior into a number of sequences. The shots were specifically taken at a time when there was no water in the pools so that the images would not be filled with myriad reflections. In addition to this, pieces of cloth were used to mute the top-light. Thus Danuser in effect recreated a studio situation inside the building, which greatly eased his analytical approach. He concentrated entirely on details of the surfaces of the various materials and on the contours in the bands of stone. The moderate format and the fact

sätzlich wurde das Oberlicht durch Tücher gemildert. Danuser stellte damit innerhalb der Architektur quasi eine Studiosituation her, die seinen analytischen Zugriff erleichterte. Er legte das Gewicht ganz auf die Detaillierung der Materialoberfläche und Konturierung der Steinschichten. Das kleine Format und der Druck der Aufnahmen auf dünnem Papier machen die Bilder leicht verfügbar und ihrerseits zu einem Objekt. Die buchstäblich ‹trockene› Art der Darstellung unterstreicht seine dekonstruierende Methode. Wie bereits bei Sogn Benedetg verzichtete Danuser darauf, die spektakuläre Landschaft zu feiern. Er interpretierte den Bau nicht als Emblem des Erhabenen, wie viele andere Fotografen es seither taten, sondern als ein Phänomen, das sich der Reduktion auf ein Bild widersetzt und weniger von Totalität handelt als von Diskontinuität.

1986: Kühltürme und Kirchtürme

Angesichts der Einöde in der traditionellen Architekturfotografie jener Jahre ist es verständlich, dass Zumthor jemanden im noch jungen Feld der künstlerischen Fotografie suchte, um eine angemessene Darstellung seines ersten grossen Projekts zu schaffen. Um seine Entscheidung besser zu verstehen, möchte ich auf Danusers Ausstellung in Chur blicken und zugleich meine eigene, damals skeptische Reaktion auf die Ausstellung *In Vivo* einer Revision unterziehen. Beide Ausstellungen gehören zu dem 1979 oder 1980 begonnenen Projekt, das in Chur noch den Titel *Wirtschaft, Industrie, Wissenschaft und Forschung* trug, 1989, um weitere Serien erweitert, aber unter dem Titel IN VIVO ausgestellt wurde und parallel als Bildband und, in Form einer Auswahl, als Ausstellungskatalog erschien (Abb. Seite 63).[7] In Chur waren Aufnahmen der Serien *A-Energie*, *Gold* und *Medizin* zu sehen. Die Aufnahmen waren, wie es im Katalog heisst, «in

7 Hans Danuser, *Drei Fotoserien*, Ausstellungskatalog Bündner Kunstmuseum Chur, 1985; Vgl. Hans Danuser, *In Vivo, 93 Fotografien in sieben Serien*, Baden, Lars Müller, 1989

that the photographs are printed on thin paper makes them readily accessible and turns them into objects in their own right. The literally 'dry' quality of their representation underpins Danuser's deconstructive method. As before in Sogn Benedetg, he chooses not to celebrate the spectacular landscape. In these images Danuser does not interpret the building as an emblem of the sublime — as many photographers have since done — but as a phenomenon that resists being reduced to a mere image and that is less about totality than discontinuity.

1986: Cooling Towers and Church Spires

In view of the bleak outlook in the realms of traditional architectural photography at the time, it was only natural that Zumthor would look for someone in the still young field of art-photography to create a fitting record of his first major project. In order to shed additional light on his final choice, I would like to take a look at Danuser's exhibition in Chur and, in so doing, also revise my own skeptical reaction to the exhibition *In Vivo*. Both exhibitions arose from a project, dating back to 1979 or 1980, that was known in Chur by

the title *Wirtschaft, Industrie, Wissenschaft und Forschung*, and that was exhibited in 1989 (now with additional series) with the title IN VIVO; at the same time it was also published as a richly illustrated book and as an exhibition catalogue with selected works (fig. page 63).[7] On view in Chur were shots from the series *A-Energie*, *Gold* and *Medizin*. As the catalogue tells us, these photographs were taken "in a nuclear power station and in the context of research into nuclear reactors," "in the context of refining, pouring, and storage," and "in the context of research in anatomy and pathology."[8] In Aarau the series *Medizin II*, *Physik I (Los Alamos)*, *Chemie I*, and *Chemie II* were also on show. When I recently revisited these works, it became clear to me that Hans Danuser's approach

7 Hans Danuser, *Drei Fotoserien*, exh. cat. Bündner Kunstmuseum Chur, 1985; see also Hans Danuser, *In Vivo, 93 Fotografien in sieben Serien*, Baden: Lars Müller, 1989.

8 Ibid.

einem Atomkraftwerk und im Bereich der Reaktorfor-
schung», «in den Bereichen Raffination, Giesserei
und Lagerung» sowie «auf dem Gebiet der Forschung
in den Bereichen Anatomie und Pathologie» aufge-
nommen worden.[8] In Aarau waren zusätzlich die Se-
rien *Medizin II*, *Physik I (Los Alamos)*, *Chemie I*
und *Chemie II* zu sehen. Bei meiner erneuten Aus-
einandersetzung mit den Aufnahmen wurde mir klar,
dass sein Ansatz nicht in erster Linie expres-
siv war, dass Hans Danuser das Erzeugen von Stim-
mungen und die Evokation des Unheimlichen weniger
wichtig waren als die Analyse. Und zwar die Ana-
lyse nicht nur des Gegenstands, sondern in erster
Linie der Art, wie ihn die Öffentlichkeit damals
wahrnahm, nämlich derart emotional, dass eine kri-
tische Auseinandersetzung mit der Rolle der Bil-
der auf der Strecke blieb. Im Rückblick ist für
mich interessant — vor fast zwanzig Jahren war es
hingegen schwer erträglich —, dass Danuser diese
Emotionalität nicht leugnet, sondern sie bei den
Betrachtern auch hervorruft. Sie sind, wie Urs
Stahel im Katalog damals treffend bemerkte, «Bild-
essays, [...] die den Betrachter auf sich selbst
zurückwerfen und ihn mit seinen ambivalenten Ge-
fühlen von Faszination und Unbehagen alleine

lassen».[9] Es ging ihm also weder um die Dekons-
truktion der Emotionalität noch um eine Desubli-
mierung, wie es beispielsweise die Fotoserien
in der Tradition der amerikanischen Conceptual Art
unternahmen, etwa diejenigen von Allan Sekula,
noch ging es ihm um die Evokation des Numinosen im
Sinne des malerischen Ansatzes von James Welling
oder Balthasar Burkhard. Seine Strategie, zumindest
in der Interpretation von Stahel, war die «Ambi-
valenz». Im Rückblick kann man davon ausgehen, dass
die Werke genau die Unentscheidbarkeit der dama-
ligen Situation artikulieren und dass sie also von
dem für die Fotografie damals charakteristischen –
gleichzeitig in der Philosophie etwa durch Jean-
François Lyotard oder Peter Sloterdijk besproche-
nen – Dilemma handeln, weder kritische Distanz
zu, noch Identifikation mit ihrem Gegenstand leisten
zu können.

8 Ebd.

9 Urs Stahel, «IN VIVO», in: *Hans Danuser, In Vivo, 93 Foto-
grafien*, Ausstellungskatalog Aargauer Kunsthaus, Aarau, 1989

was not primarily expressive, that for him the
creation of atmosphere and the evocation of the
uncanny were less important than analysis — not
only the analysis of an object, but above all of
the way that the public perceived it in those days.
For the public's reaction could be so emotional
that any chance of critical reflection on the role
of the pictures just fell by the wayside. With
hindsight I find it interesting — almost twenty
years ago it was scarcely tolerable — to see that
Danuser does not deny this emotionality, but even
nurtures it in the viewer. As Urs Stahel aptly
put it in the catalogue, these are "picture essays
[...] that throw the viewer back on his own de-
vices, leaving him to contemplate his ambivalent
feelings of fascination and unease."[9] So Danuser
was not out to deconstruct emotionality, nor to un-
do the sublime — as in the photo-series of certain
American conceptual artists such as Allan Sekula —

nor was he endeavoring to evoke the numinous,
in the spirit of painters such as James Welling and
Balthasar Burkhard. His strategy, or so Stahel
sees it, was the pursuit of "ambivalence." Looking
back now, it seems clear that his work articu-
lated precisely the indeterminate nature of the
situation in those days and that it was also ad-
dressing a dilemma that was very much a live issue
in the photography of the day (discussed by phil-
osophers such as Jean-François Lyotard and Peter
Sloterdijk), namely the problem of the camera
neither being able to establish a critical distance
to its own subject matter, nor being able to
identify with it.
Danuser had taken pictures in a variety of places,
for instance in nuclear power stations in Switz-
erland, Germany, the USA, and France. However, his
aim was not to identify his shots with particu-
lar places, as a documentary photographer would do,
but rather to represent general types.[10] He showed
how human beings had penetrated the very heart
of matter, the innermost workings of the mechanisms
of life, how they seek to control and manipulate

9 Urs Stahel, "IN VIVO", in: *Hans Danuser, In Vivo, 93 Foto-
grafien*, exh. cat. Aargauer Kunsthaus, Aarau, 1989

10 Hans Danuser, in conversation with Philip Ursprung, 11 June
2008

Danuser hatte an unterschiedlichen Orten fotografiert, beispielsweise in Atomenergieanlagen in der Schweiz, Deutschland, den USA und Frankreich. Es ging ihm nicht darum, die Aufnahmen spezifischen Orten zuzuordnen, wie in der Dokumentarfotografie, sondern vielmehr allgemeine Typen darzustellen.[10] Er zeigte, wie die Menschen ins Innere der Materie, ins Innere der Mechanismen des Lebens eingedrungen sind, wie sie die Kräfte der Natur zu kontrollieren und manipulieren suchen und zugleich an die Grenzen des sinnlich und begrifflich Fassbaren stossen. Es handelt sich um Orte der Macht, die sich der Repräsentation entziehen. Orte, die einerseits den meisten Menschen unzugänglich waren, die andererseits die kollektive Imagination damals beschäftigten, also die Kontrolle von Naturkräften, von menschlichem Leben, von natürlichen Ressourcen. Sein Ansatz verband die Methode der Reportagefotografie, also Kleinbildaufnahmen, wechselnde Perspektiven, die von einem mobilen Betrachterstandpunkt zeugen, mit dem künstlerischen Anspruch der allgemeinen Gültigkeit des Sujets, der Totalität und der verdichteten formalen Wirkung des einzelnen Bildes. Der Titel IN VIVO, also das, was in der Wissenschaft einen im lebendigen Organismus ablaufenden Prozess bezeichnet – im Gegensatz zu Prozessen, die ausserhalb von lebendigen Organismen ablaufen und «In Vitro» genannt werden –, deutet auf diese Unmöglichkeit der Distanzierung hin. Heute würde man wohl den Begriff der «Biopolitik» oder den von Michel Foucault in den 1970er-Jahren geprägten Begriff der «Bio-Macht» wählen, um den Aspekt der Machtausübung und institutionellen Kontrolle noch stärker zu betonen.

Es ist gut nachvollziehbar, warum Zumthor sich damals für Danusers Ansatz interessierte. Einerseits ist sein eigener Entwurf stark von Bildern motiviert, das heisst, er zielt darauf, bestimmte mentale Bilder räumlich umzusetzen. Er war zweifellos fasziniert, dass Danuser fast ausschliesslich Innenräume zeigte. Dies dürfte seiner Entwurfspraxis entsprochen haben, die stets vom Inne-

10 Hans Danuser, Gespräch mit Philip Ursprung, 11. Juni 2008

"bio-power" coined by Michel Foucault in the 1970s, in order to lend extra weight to the notion of power and institutional controls.

One can readily understand why Zumthor was attracted by Danuser's approach. On one hand his own designs are based on images, that is to say, his intention is to give three-dimensional expression to particular images in his mind's eye. He must have been fascinated by the fact that Danuser concentrated almost exclusively on interiors. He may have felt an affinity here with his own design methods that always work out from the inside and that assume an element of discontinuity, in other words, that assume it is impossible for the interior to fully correspond to the exterior. But most importantly, it seems to me, his own work — like that of Danuser — is about articulating latent processes, about envisioning the invisible. This is very clear, for instance, in his Shelters for the Roman archeological site in Chur (1986), where the architectural shell not only echoes the contours of long-gone Roman houses, it also directs the viewer's gaze to the scarcely visible remnants of a lost civilization; this comes out all the more clearly in Danuser's photographic in-

the forces of Nature, and how, in the process, they are stopped in their tracks by the limits of what human senses and minds can cope with. His work was about centers of power that elude representation: places that were inaccessible to most people yet preoccupied the collective imagination in those days with thoughts of taming the forces of Nature, of human life, of natural resources. Danuser's approach combined the methods of photo-reportage — small-format shots, shifting perspectives that reflect a mobile viewpoint — with artistic aspiration that strove for images that would have a wider relevance, for totality, and for formal coherence in each individual image. The term "in vivo", used by scientists to describe a process that runs its course within a living organism — in contrast to the processes that are managed outside a living organism and are referred to as "in vitro" — points to the impossibility of achieving any real distance. Nowadays one might cite the concept of "biopolitics" or the notion of

ren aus gedacht ist und von der Diskontinuität des Raums ausgeht, also von der Unmöglichkeit, dass das Innen und das Aussen sich entsprechen. Am wichtigsten aber scheint mir zu sein, dass sein eigenes Werk wie das von Danuser um die Artikulation von latenten Prozessen beziehungsweise um die Visualisierung des Unsichtbaren kreist. Deutlich wird dies beispielsweise bei den Schutzbauten für Ausgrabungen römischer Funde in Chur (1986), wo die architektonische Hülle einerseits die Konturen der einstigen römischen Häuser nachzeichnet, andererseits den Blick auf die kaum mehr sichtbaren Reste einer verschwundenen Kultur lenkt; dies wird in der fotografischen Interpretation Danusers noch unterstrichen (Abb.). In Sogn Benedetg ist das Unsichtbare einerseits der religiöse Glaube, dessen

Visualisierung seit der Antike ein Thema von Architektur, Malerei und Skulptur ist. Andererseits die komplexe historische, ökonomische und soziale Struktur der Surselva, also ein Thema, welches durch das Klischee der heilen Bergwelt verdrängt und seinerseits unsichtbar gemacht wurde.

Beim Vergleich zwischen den Aufnahmen von Sogn Benedetg und IN VIVO fällt auf, wie ähnlich sich das erste Bild der Kapelle und das Bild des Atom-Kraftwerks sind. IN VIVO beginnt mit der Aufnahme aus dem Inneren eines Kühlturms (Abb.). Während die Silhouetten der Kühltürme als visuelle Zeichen allgegenwärtig sind, entzieht sich deren Inneres der Darstellbarkeit. Der dunkle, nur spärlich von oben erhellte Raum ist von Nebelschwaden durchzogen. Wären die schrägen Betonpfeiler nicht zu sehen – und wäre da nicht der Titel *Kühlturmtasse* – könnte man sich genausogut in einer Kathedrale,

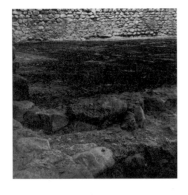

SCHUTZBAUTEN ÜBER RÖMISCHEN FUNDEN, II 2, Fotografien auf Barytpapier, 7-teilig, I, II 1-3 , III, IV 1- 2, je auf Papierformat 50 x 40 cm, 1988

SHELTERS FOR THE ROMAN ARCHAEOLOGICAL SITE, II 2, photographs on baryt paper, 7 parts, I, II 1-3, III, IV 1-2, format of each print 50 x 40 cm, 1988

terpretation (fig.). In Sogn Benedetg the "invisible" is the religious faith that architects, painters, and sculptors have sought to portray ever since Antiquity. But it is also the complex historical, economic, and social makeup of the Surselva, a topic that was for its part too often sidelined and rendered invisible by the cliché of the intact mountain region.

Comparing the images of Sogn Benedetg and the works shown in IN VIVO, one cannot help but be struck by the similarity between the first picture of the chapel and the picture of the nuclear A-Power Station. IN VIVO opened with a shot taken inside

a cooling tower (fig.). While the silhouettes of cooling towers are a familiar visual sign, the interior of these towers all but defies representation. The dark space, only dimly lit from above, is filled with swathes of mist. Were it not for the sloping concrete columns — and for the title *Kühlturmtasse* — one might easily take this for a cathedral, a tunnel, or even a factory site at night. This shot of the dark interior matches the shots of the pale upper edge of the cooling tower that show the thin concrete wall cloaked in mist. And in the same vein, one might easily imagine this shot were taken from a viewing platform in the Alps or on the crest of a dam. The natural phenomenon of the mist mingles with industrially produced steam. The invisible threat inherent in the technology — the explosion of the reactor at Chernobyl in the Soviet Union on 26 April 1986 had drastically demonstrated the deadly danger of nuclear power — counters the atmospheric beauty of the intrinsically perfectly harmless water vapor.

Once again we could do with a small digression into the past. In the 1950s the construction of hydro-electric power stations in Grisons heralded a

in einem Tunnel, ja auf einem nächtlichen Fabrik-
gelände wähnen. Die Aufnahme vom dunklen Inneren
korrespondiert mit den Aufnahmen vom hellen oberen
Rand des Kühlturms, welche die dünne Betonwand
im Nebel zeigen. Auch hier könnte man sich ebenso
gut auf einer Aussichtsplattform in den Alpen oder
auf der Krone einer Staumauer wähnen. Das natür-
liche Phänomen des Wetters verschwimmt mit dem
industriell produzierten Dampf. Die von der Tech-
nologie ausgehende unsichtbare Bedrohung – die
Explosion des Reaktors im sowjetischen Tschernobyl
am 26. April 1986 hatte die tödliche Gefahr da-
mals der Weltöffentlichkeit drastisch vor Augen
geführt – steht der stimmungsvollen Schönheit des
an sich völlig harmlosen Wasserdampfes gegenüber.

Hier ist abermals eine kurze Rückblende angebracht.
Graubünden erfuhr ab den 1950er-Jahren eine ra-
sante Entwicklung durch den Bau von Wasserkraftwer-
ken. Zusammen mit dem Tourismus war die Energie-
wirtschaft der Motor der Entwicklung, und viele
Berggemeinden, darunter beispielsweise Vals, ver-
danken ihren Wohlstand den Kraftwerken, das heisst,

dem Bau der grossen Anlagen und dem durch die
Nutzung des Wassers fälligen Wasserzins. Die Nord-
ostschweizerische Kraftwerke AG (NOK) waren seit
den 1950er-Jahren die treibende Kraft dieser Ent-
wicklung. Ab 1950 entstand der Plan, in der Re-
gion Surselva eines der grössten Kraftwerksysteme
der Schweiz zu realisieren, mit sieben grossen
Speicherseen, 140 km Stollen, acht Zentralen und
einer Jahresproduktion von 2000 GWh, also fast
ein Viertel eines Kernkraftwerks.[11] Auch wenn nur
Teile des Projekts realisiert wurden, veränder-
te es die Region nachhaltig. Die Wasserkraftwerke,
etwa die 1962 bis 1968 in der oberen Surselva

11 Vgl. Hansjürg Gredig, Walter Willi, *Unter Strom. Wasser-
kraftwerke und Elektrifizierung in Graubünden 1879–2000*,
hg. vom Verein für Bündner Kulturforschung, Chur, Bündner
Monatsblatt, 2006, S. 326

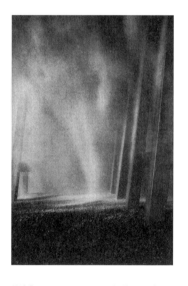

Kühlturmtasse aus *A-Energie*, 16 Fotografien auf Barytpapier,
je auf Papierformat 50 x 40 cm, 1983, aus: IN VIVO, 1989–1989

Cooling Tower Cup from *A-Energie*, 16 photographs on baryt
paper, format of each print 50 x 40 cm, 1983, from: IN VIVO,
1989–1989

period of rapid economic growth. This and tourism
drove the region's upsurge, and many mountain
communities — including Vals, for instance — owe
their prosperity to these power stations, that
is to say, to the construction of large-scale com-
plexes and the payments levied for the water these
use. Since the 1950s the Nordostschweizerische
Kraftwerke AG (NOK) has been the main player in
these developments. In 1950 a plan was first mooted
to construct one of Switzerland's largest power-
station systems in the Surselva, with seven giant
reservoirs, 140 km of tunnels, eight operating
stations, and an annual output of 2000 GWh, almost
a quarter of the capacity a nuclear power sta-
tion would produce.[11] Even although these plans
were only partially realized, the region was fun-
damentally affected. The hydro-electric power
stations — Vorderrhein, built between roughly 1962

11 See Hansjürg Gredig and Walter Willi, *Unter Strom,
Wasserkraftwerke und Elektrifizierung in Graubünden 1879–2000*,
ed. by Verein für Bündner Kulturforschung, Chur, Bündner
Monatsblatt, 2006, p. 326

and 1968 in the upper Surselva, and Ilanz (con-
structed between 1984 and 1992) with its compli-
cated systems of reservoirs, tunnels, and opera-
tions centers — literally ploughed up the wider
mountain landscape around Sumvitg. This region is
now inextricably connected with the factories
and transportation routes in the heavily populated
areas of Switzerland's heartlands. The nuclear
power stations run by NOK at Gösgen (since 1979)
and Leibstadt (since 1984) are connected with
numerous pumping stations in the Alps, that is to
say, cheap energy is used to pump water up into

errichteten Kraftwerke Vorderrhein oder die 1984
bis 1992 entstandenen Kraftwerke Ilanz mit ihren
verzweigten Systemen von Stauseen, Stollen und
Kraftwerkbauten, pflügten die Berglandschaft in der
Region, in der Sumvitg liegt, buchstäblich um.
Die Gegend ist mit den Fabriken und Verkehrslinien
in den Ballungszentren des Mittellandes untrenn-
bar verbunden. Die von der NOK kontrollierten
Kernkraftwerke Gösgen (ab 1979) und Leibstadt (ab
1984) sind mit vielen Pumpspeicherkraftwerken in
den Alpen verbunden, das heisst, mit deren billi-
ger Energie wird Wasser in Stauseen hochgepumpt
und so in teure Energie verwandelt. Allerdings ist,
im Unterschied zu den weithin sichtbaren Kühl-
türmen der Atomkraftwerke, der grösste Teil der In-
frastruktur in den Alpen kaum zu sehen und in
der Wahrnehmung der Touristen gänzlich verdrängt.
Sichtbar wurde das Problem Ende der 1970er-Jahre,
als erstmals eine breite Öffentlichkeit gegen
den Plan der NOK, die Greina-Ebene für einen Stau-
see unter Wasser zu setzen, mobilisiert wurde.[12]

12 Vgl. *La Greina. Das Hochtal zwischen Sumvitg und
Blenio*, Schweizerische Greina-Stiftung (SGS), Verlag Bündner
Monatsblatt, Chur, 1997

Die Auseinandersetzung zog sich über mehr als ein
Jahrzehnt hin. 1986 gaben die NOK das Projekt
unter dem Druck des öffentlichen Widerstandes und
der Politik schliesslich auf. Um die durch den
Verzicht auf die Einnahmen aus den Wasserrechten
benachteiligten Gemeinden Vrin und Sumvitg, auf
deren Gebiet die Greina liegt, zu entschädigen, er-
hielten diese 1986 erstmals einen symbolischen Be-
trag aus Spendengeldern. Nach einer nationalen
Volksabstimmung 1992 und der Umsetzung der Gesetze
im Parlament 1995, bekannt unter dem Begriff «Land-
schaftsrappen», konnte der finanzielle Ausgleich
für den Landschaftsschutz auf nationaler Ebene
durchgesetzt werden. Seither erhält beispielswei-
se die Gemeinde Sumvitg eine jährliche Entschä-
digung von über 500.000 Franken.[13]

13 Vgl. Aluis Maissen, *Sumvitg/Somvix, Eine kulturhistorische
Darstellung*, Gemeinde Sumvitg, 2000, S. 218

the reservoirs where it is turned into expensive
energy. Although it has to be said that, in cont-
rast to the cooling towers of the nuclear power
stations that are visible far and wide, for the
main part the infrastructure in the Alps is barely
visible and wholly suppressed in tourists' per-
ceptions of the landscape. The problem only attrac-
ted attention in the late 1970s when large numbers
of ordinary people were mobilized to protest
against NOK's proposal to create a new reservoir
that would flood the Greina plain.[12] The ensuing
conflict dragged on for over a decade. In 1986, NOK
finally yielded to public and political pressure
and abandoned its plans. Subsequently the parishes
of Vrin and Sumvitg, which include the Greina
in their terrain and were deemed to have been dis-
advantaged by the loss of potential earnings from
water rights, were offered compensation and in
1986 received a first symbolic payment from dona-

12 See *La Greina, Das Hochtal zwischen Sumvitg und Blenio*,
Schweizerische Greina-Stiftung (SGS), Verlag Bündner Monats-
blatt, Chur, 1997

tions. Following a national referendum in 1992
and the passing of the relevant laws — nicknamed
the "Landschaftsrappen" — in Parliament in 1995,
financial compensation for preserving the landscape
by non-exploitation were introduced throughout the
country. Since then, a community such as Sumvitg,
for instance, receives annual compensation of over
500,000 Swiss francs.[13]

It could therefore be said that there is an eco-
nomic connection between the photographs Danuser
took in the nuclear power station at Gösgen in
1981 and the shots he took in 1988 of Sogn Benedetg
(fig.).[14] Both reflect burning issues in the 1980s
in the politics of the nation's energy supply. The
fragile chapel in the mountains with their poten-
tial for destruction — albeit themselves already
partially destroyed by industry — stands in stark
contrast to the rawness of the power station in the

13 See Aluis Maissen, *Sumvitg/Somvix, Eine kulturhistorische
Darstellung*, Gemeinde Sumvitg, 2000, p. 218

14 The shots inside and outside, on the cooling tower of the
nuclear power station come at the beginning of the cycle.
According to Danuser they were taken in 1981 in Gösgen.
See also Cornelius Krell, "Formale Elemente der fotografischen
Bildsprache bei Hans Danuser," licentiate dissertation,
Phil. Fakulty of the University of Zürich, Arthistorical In-
stitute, 2007

Aus wirtschaftsgeschichtlicher Perspektive besteht somit ein Zusammenhang zwischen Danusers im Atomkraftwerk Gösgen 1981 entstandenen Aufnahmen und seinen 1988 entstandenen Aufnahmen von Sogn Benedetg (Abb.).[14] Beides sind Brennpunkte der energiepolitischen Diskussion jenes Jahrzehnts. Die fragile Kapelle in den Bergen in ihrer potenziell zerstörerischen – aber durch die Industrie auch teilweise zerstörten – Landschaft steht im Kontrast zur Rohheit des Kraftwerks im Mittelland. Und zugleich hängt sie von dessen Betrieb ab. Denn ohne die Wertschöpfung der Energieindustrie und ohne die Leistung der Kernkraftwerke wäre, so kann zumindest vermutet werden, die Politik damals nicht in der Lage gewesen, den Bau weiterer Wasserkraftwerke im Gebirge zu bremsen und damit die für die Tourismusindustrie wichtige Illusion einer intakten Landschaft und einer domestizierten Natur zu erhalten.

14 Die Aufnahmen im Inneren und auf dem Kühlturm des Atomkraftwerks standen am Beginn des Zyklus'. Laut Danuser entstanden sie 1981 in Gösgen. Vgl. auch Cornelius Krell, «Formale Elemente der fotografischen Bildsprache bei Hans Danuser», Lizentiatsarbeit der Philosophischen Fakultät der Universität Zürich, Kunsthistorisches Institut, 2007

Weder Zumthor noch Danuser erwähnen den Zusammenhang zwischen der Kapelle in den Bergen und der Energiediskussion, also die Ausbeutung der Berglandschaft durch die Energiekonzerne, explizit, obwohl beide ihn zweifellos kannten. Sie waren der Region durch ihre Herkunft beziehungsweise im Fall von Zumthor durch die berufliche Praxis eng verbunden. Zumthor war während der 1970er-Jahre als Mitarbeiter der Kantonalen Denkmalpflege mit der Dialektik von Modernisierung und Zerstörung vertraut und kannte die Umwälzungen durch die beispiellose Bautätigkeit jener Jahre aus der täglichen Praxis. Gemeinsam mit anderen kulturell

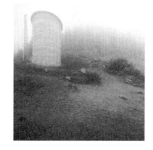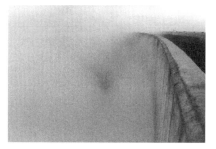

CAPLUTTA SOGN BENEDETG, SUMVITG, I, Fotografien auf Barytpapier, 6-teilig, I, II 1-2, III, IV 1-2, je auf Papierformat 50 x 40 cm, 1988

CAPLUTTA SOGN BENEDETG, SUMVITG, I, photographs on baryt paper, 6 parts, I, II 1-2, III, IV 1-2, format of each print 50 x 40 cm, 1988

Kühlturm aus *A-Energie*, 16 Fotografien auf Barytpapier, je auf Papierformat 50 x 40 cm, 1983, aus IN VIVO, 1989–1989

Cooling Tower from *A-Energie*, 16 photographs on baryt paper, format of each print 50 x 40 cm, 1983, from IN VIVO, 1989–1989

heartlands. And yet the former is dependent on the latter. For it seems reasonable to assume that without the wealth created by the energy industry and without the output from nuclear power stations, politicians would not have been in a position to halt the construction of additional hydro-electric plants in the mountains and hence to preserve the illusion of an intact landscape and domesticated Nature that is so important for the tourist industry.

Neither Zumthor nor Danuser allude to the connection between the chapel in the mountains and the energy debate, that is to say, the exploitation of the mountain landscape by the energy companies, although both were no doubt aware of this. They had close links with the region by dint of their roots and in Zumthor's case, through his work. During the 1970s, when he was working for the cantonal department of historic monuments he encountered the dialectics of modernization and destruction first-

hand and knew from his daily praxis the extent of the upheaval in the landscape that ensued from the unprecedented level of construction work going on at the time. Together with other culturally and politically active colleagues in the Bündner Heimatschutz, he set about helping to turn the Bündner Heimatschutz into the institution it is today, with its very particular importance for the region's architecture and landscape. Thus he knew a great deal about the forces that were threatening the ethos of building and construction in the Canton of Grisons. However, I would venture to suggest that the connection between cutting-edge architecture in an apparently intact landscape

und politisch engagierten Mitarbeitern des Bündner Heimatschutzes setzte er sich dafür ein, den Heimatschutz zu jener wichtigen Architektur- und Landschaftsinstitution zu machen, die er heute ist. Er wusste daher viel über die Kräfte, die der Baukultur des Kantons Graubünden zusetzten. Der Zusammenhang zwischen der neuesten Architektur in einer scheinbar intakten Berglandschaft und der Atomenergie aber, so meine Behauptung, konnte damals nur im Medium der Fotografie, genauer gesagt mittels einer Fotografie, die sich als künstlerisch verstand, artikuliert werden. Danuser ging weit über die Reportagefotografie hinaus, indem er sich statt auf das Klischee des Kühlturms auf die Problematik des Unsichtbaren konzentrierte. Und er ging über die Konventionen der Architekturfotografie hinaus, indem er seinen Gegenstand nicht abbildete, sondern interpretierte, ja künstlerisch übersetzte. Er entwickelte eine eigene Perspektive, welche es mir, zumindest aus zeitlicher Distanz,

erst erlaubte, die scheinbar disparaten Gegenstände zusammen wahrzunehmen. Möglich war diese Verbindung, weil sich damals für kurze Zeit die Gattungsgrenzen gelockert hatten und die Bilder gleichsam der gemeinsame Nenner waren: Die Architektur, verunsichert über ihren Ort in der Gesellschaft, bestrebt, aus der Isolation der Fachwelt herauszukommen, vertraute die Vermittlung für einen kurzen Moment der Fotografie an. Und die Fotografie, auf dem Weg zur künstlerischen Autonomie, befand sich in einer ganz neuen, freien Situation, welches ihr ermöglichte, Zusammenhänge, die sich begrifflich gar nicht fassen liessen, als Bilder zu artikulieren. Zumthor also, bemüht, sich vom Denkmalpfleger zum Architekten zu wandeln, legte die Verantwortung vorübergehend in die Hände eines Künstlers. Danuser wiederum, bestrebt, sich vom Fotografen zum Künstler zu wandeln, liess sich vorübergehend auf eine Auftragsarbeit ein. Diese Konstellation war ein kulturhistorischer Glücksfall. Inzwischen sind die Felder zwischen Architektur und Fotografie wieder unterteilt und ihre Protagonisten gehen getrennte Wege. Aber dennoch wird nichts im Bereich der Architekturdarstellung so sein wie früher.

Für Gespräche und Präzisierungen danke ich Hans Danuser, Köbi Gantenbein, Nadine Olonetzky und Peter Zumthor.

and nuclear power could, in those days, only be demonstrated through the medium of photography, or rather, through photography that was overtly artistic. Danuser went far beyond reportage photography when he chose to address the problem of the invisible rather than succumbing to the cooling-tower cliché. And he abandoned the conventions of architectural photography when he chose not merely to illustrate his subject matter, but also to interpret it, to transpose it into a different artistic medium. He developed his own perspective which has allowed me — at least with hindsight — to connect seemingly disparate factors. And it was possible to make this connection because, at the time, for a short while the barriers between different genres had been lowered and the photographs became the common denominator. For one short moment, architecture, uncertain of its role in society and striving to escape the isolation of its own ivory towers, put its trust in the mediating powers of photography. And photography, well on the way to artistic autonomy, was enjoying a wholly new freedom that allowed it to use images

to make connections that could not be expressed in words. And so it was that Zumthor, keen to make the move from historic monuments to architecture, briefly delegated at least some responsibility to an artist. And Danuser, for his part, keen to turn himself from photographer into artist, was willing, by way of an exception, to take on the occasional commission. In terms of cultural history, this chance constellation was more than fortuitous. By now architecture and photography have once again staked out their own territories and their exponents go their separate ways. But even so, nothing in the realms of architectural photography will ever be as it was in the now distant past.

With sincere gratitude for conversations and calibration to Hans Danuser, Köbi Gantenbein, Nadine Olonetzky, and Peter Zumthor.

Schutzbauten über römischen Funden in Chur

Bilder von Hans Danuser

Shelters for the Roman archaeological site in Chur

Images by Hans Danuser

I

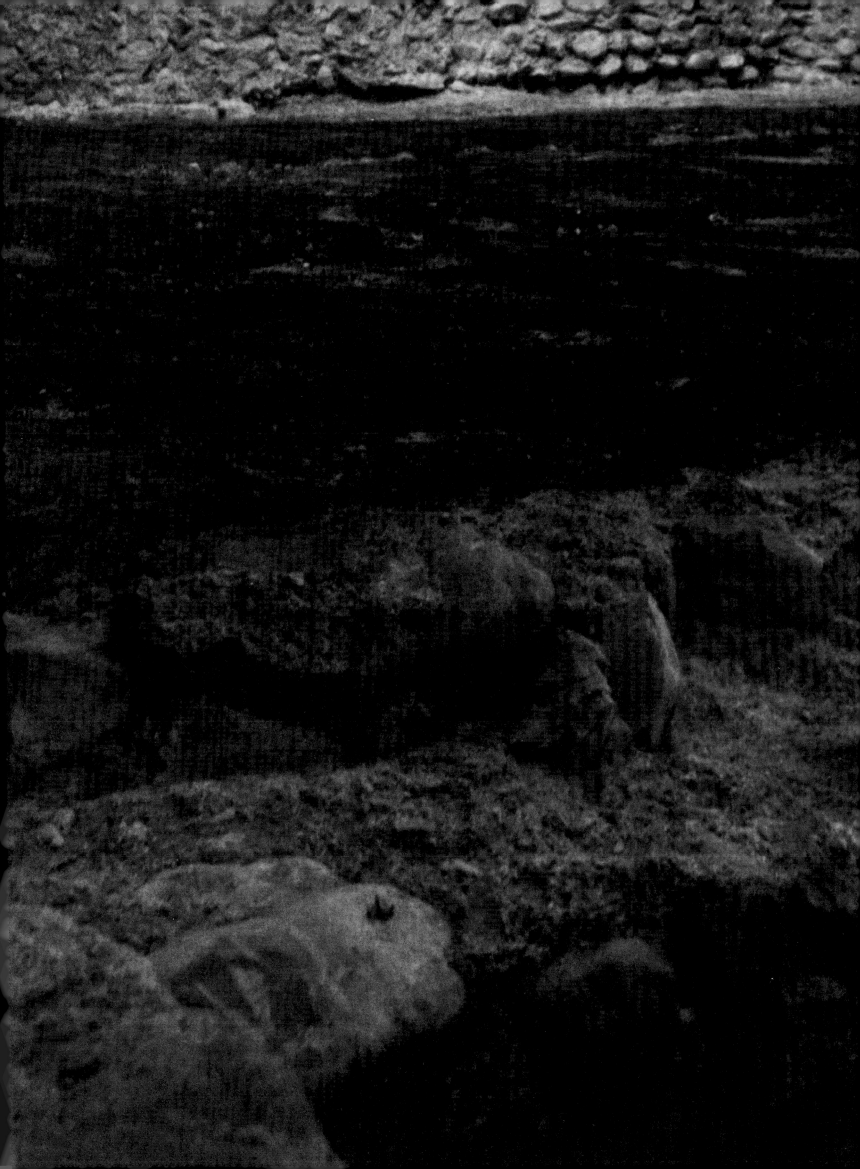

SCHUTZBAUTEN ÜBER RÖMISCHEN FUNDEN, II 2, Fotografien
auf Barytpapier, 7-teilig, I, II 1– 3, III, IV 1-2, je auf
Papierformat 50 x 40 cm, 1988

SHELTERS FOR THE ROMAN ARCHAEOLOGICAL SITE, II 2,
photographs on baryt paper, 7 parts, I, II 1-3, III, IV 1-2,
format of each print 50 x 40 cm, 1988

I

Hans Danuser (*1953 in Chur) gehört zu den Weg-
bereitern zeitgenössischer Fotografie. Seine Werke
wurden in bedeutenden Ausstellungen im In- und
Ausland gezeigt. Er wurde zu internationalen Ver-
anstaltungen wie der Biennale in Venedig oder
Lyon eingeladen und mit zahlreichen Preisen ausge-
zeichnet, u.a. mit dem Conrad-Ferdinand-Meyer-
Preis, dem Manor-Kunstpreis und dem Bündner Kultur-
preis. Seit 1992 beschäftigt er sich auch mit
Kunst in Architektur-Projekten, so an der Univer-
sität Zürich, im Peter Merian Haus Basel 1999
und in der Klinik Beverin 2001. www.hansdanuser.ch

Köbi Gantenbein (*1956 in Samedan) ist seit 1996
Chefredaktor von *Hochparterre*, dem Verlag für
Architektur und Design. Er lebt und arbeitet in
Zürich und Fläsch, Graubünden. Er schreibt in
Hochparterre regelmässig Berichte über die zeitge-
nössische Architektur Graubündens und den Schre-
cken und die Schönheit der Alpen. www.hochparterre.ch

Philip Ursprung (*1963 in Baltimore, MD) studierte
Kunstgeschichte, Allgemeine Geschichte und Ger-
manistik in Genf, Wien und Berlin. Er wurde 1993
an der FU Berlin promoviert und 1999 an der ETH
Zürich habilitiert. Er unterrichtete an den Univer-
sitäten Genf, Basel und Zürich, an der ETH Zü-
rich, der Kunsthochschule Berlin-Weissensee und der
Universität der Künste Berlin. 2001–2005 war er
Nationalfonds-Förderungsprofessor für Geschichte
der Gegenwartskunst am Departement Architektur
der ETH Zürich. Seit 2005 ist er Professor für mo-
derne und zeitgenössische Kunst an der Universi-
tät Zürich. 2007 war Philip Ursprung Gastprofessor
an der Graduate School of Architecture, Planning
and Preservation der Columbia University New York.
Er war Gastkurator am Museum für Gegenwartskunst
in Basel, am Canadian Centre for Architecture in
Montreal und an der Graduate School for Archi-
tecture, Planning and Preservation der Columbia
University New York. www.khist.uzh.ch

86

Hans Danuser (*1953 in Chur) is one of the pio-
neers of contemporary photography. His work
has been shown in important exhibitions both in
Switzerland and abroad. He has been invited
to participate in the Venice Biennale, the Lyon
Biennial, and other international events and
has received numerous awards, including the Con-
rad-Ferdinand-Meyer Prize, the Manor Art Prize,
and the Cultural Achievement Award of the Canton
of Grisons. Works on his art-in-architecture
projects since 1992 at such sites as the Univer-
sity of Zurich, the Peter Merian Building in
Basel in 1999, and the Psychiatric Clinic Beverin
2001. www.hansdanuser.ch

Köbi Gantenbein (*1956 in Samedan), since 1996
editor in chief of *Hochparterre*, publishers for
architecture and design. Lives and works in
Zurich and Fläsch, Grisons. He contributes regu-
larly to *Hochparterre*, mainly writing articles
about contemporary architecture in Grisons and the
bane and beauty of the Alps. www.hochparterre.ch

Philip Ursprung (*1963 in Baltimore, MD) studied
art history, general history, and German lite-
rature in Geneva, Vienna, and Berlin. Earned his
doctorate at the FU Berlin in 1993 and became
a full professor at the Swiss Federal Institute
of Technology Zurich in 1999. Taught at the Univer-
sities of Geneva, Basel, and Zurich, the Swiss
Federal Institute of Technology (ETH) Zurich, the
Berlin Weissensee School of Art, and the Berlin
University of the Arts. 2001–2005, held a profes-
sorship for the history of contemporary art at
the Architecture Department of the ETH, funded by
the Swiss National Science Foundation. He has
been professor of modern and contemporary art at
the University of Zurich's Institute of Art His-
tory since the fall semester of 2005. In 2007
he was visiting professor at the Graduate School
of Architecture, Planning and Preservation at
Columbia University in New York. He served as guest
curator at the Museum für Gegenwartskunst in
Basel, at the Canadian Centre for Architecture
in Montreal, and at the Graduate School of Archi-
tecture, Planning and Preservation at Columbia
University in New York. www.khist.uzh.ch

Peter Zumthor (*1943 in Basel) absolvierte zuerst
eine Ausbildung als Möbelschreiner bei seinem
Vater, anschliessend studierte er Innenarchitek-
tur und Design an der Kunstgewerbeschule Basel
sowie Architektur und Industrial Design am Pratt
Institute in New York. Zehn Jahre lang arbei-
tete er als Denkmalpfleger des Kantons Graubünden.
Peter Zumthor lebt und arbeitet in Haldenstein
bei Chur, seit 1979 mit einem eigenen Architektur-
büro. Wichtigste Bauten: Schutzbauten für die
Ausgrabung römischer Funde, Chur 1986; Caplutta
Sogn Benedetg, Sumvitg 1988; Wohnungen für Betagte,
Chur-Masans 1993; Therme Vals, 1996; Kunsthaus
Bregenz, 1997; Schweizer Pavillon Expo 2000, Han-
nover; Dokumentationszentrum «Topographie des
Terrors», 1997, ausgeführte Bauteile 2004 vom Land
Berlin abgebrochen; Haus Zumthor, Haldenstein
2005; Kunstmuseum Kolumba, Köln 2007; Feldkapelle
für den Heiligen Bruder Klaus, Wachendorf, Eifel
2007. 2008 erhält Peter Zumthor den Internationa-
len Kunst- und Kulturpreis Praemium Imperiale
in der Kategorie Architektur der Japan Art Asso-
ciation.

Peter Zumthor (*1943 in Basel), apprenticeship as
a cabinetmaker with his father, studied interior
design at the College of Applied Arts Basel and ar-
chitecture and industrial design at the Pratt
Institute in New York. Worked for the Department
for the Preservation of Monuments of the canton
of Grisons for ten years. Peter Zumthor lives and
works in Haldenstein near Chur, since 1979 he
has been running his own architectural practice in
Haldenstein. His most important buildings inc-
lude Shelters for the Roman archaeological site,
Chur 1986; Sogn Benedetg Chapel, Sumvitg 1988;
Residential home for the elderly, Chur-Masans 1993;
Therme Vals, 1996; Kunsthaus Bregenz, 1997; Swiss
Pavilion Expo 2000, Hanover; documentation Centre
"Topography of Terror", 1997, construction was
aborted by the state of Berlin in 2004; Zumthor
House, Haldenstein 2005; Kolumba Art Museum, Co-
logne 2007;Chapel for Brother Klaus, Wachendorf,
Eifel 2007. In 2008 Peter Zumthor was awarded the
Japan Art Association's global arts prize the
Praemium Imperiale in the category of architecture.

Impressum
Fotografie: Hans Danuser
Texte: Hans Danuser, Köbi Gantenbein, Philip Ursprung
Redaktion: Nadine Olonetzky
Deutsches Korrektorat: Yasmin Kiss, Zürich
Übersetzungen: Kimi Lum, Fiona Elliott (Text Philip Ursprung)
Englisches Korrektorat: Claudia Mazanek, Wien
Gestaltung: Susanne Kreuzer, Zürich, sus.kreuzer@gmail.com
Schrift: Akkurat Mono
Papier: Tatami White, Munken Print White, Sirio Color;
Fischerpapier
Lithografie: Egli, Kunz & Partner, Glattbrugg
Druck und Bindung: DZA Druckerei zu Altenburg GmbH, Thüringen
Dank an: Christian Dettwiler, das Gelbe Haus, Flims;
Jürg Ragettli, Bündner Heimatschutz, Chur
Copyright für die Fotografien: Hans Danuser
Copyright für die Texte: die Autoren

Die vorliegende Publikation wurde ermöglicht durch:
Bündner Heimatschutz · Cumissiun Greina · Gemeinde Sumvitg ·
Kulturförderung, Kanton Graubünden · Präsidialdepartement der
Stadt Zürich · Pro Raetia · Stiftung Dr. M. O. Winterhalter ·
Stiftung Erna und Curt Burgauer · Stiftung Stavros S. Niarchos,
Chur · Willi Muntwyler-Stiftung St. Moritz

Edition Hochparterre bei Scheidegger & Spiess
Herausgeber: Köbi Gantenbein
© 2009 Verlag Hochparterre und Verlag Scheidegger & Spiess AG,
Zürich
ISBN 978-3-85881-235-3
www.hochparterre.ch
www.scheidegger-spiess.ch

Imprint
Photography: Hans Danuser
Texts: Hans Danuser, Köbi Gantenbein, Philip Ursprung
Copy editing German: Nadine Olonetzky
Proofreading German: Yasmin Kiss, Zurich
Translations: Kimi Lum, Fiona Elliott (Text Philip Ursprung)
Proofreading English: Claudia Mazanek, Vienna
Design: Susanne Kreuzer, Zurich, sus.kreuzer@gmail.com
Font: Akkurat Mono
Paper: Tatami White, Munken Print White, Sirio Color;
Fischerpapier
Lithography: Egli, Kunz & Partner, Glattbrugg
Printed and bound by: DZA Druckerei zu Altenburg GmbH, Thüringen
Thanks to: Christian Dettwiler, das Gelbe Haus, Flims;
Jürg Ragettli, Bündner Heimatschutz, Chur
Copyright for the photographs: Hans Danuser
Copyright for the texts: the authors

The publication of this book has been enabled by:
Bündner Heimatschutz · Cumissiun Greina · Gemeinde Sumvitg ·
Kulturförderung, Kanton Graubünden · Präsidialdepartement der
Stadt Zürich · Pro Raetia · Stiftung Dr. M. O. Winterhalter ·
Stiftung Erna und Curt Burgauer · Stiftung Stavros S. Niarchos,
Chur · Willi Muntwyler-Stiftung St. Moritz

Edition Hochparterre bei Scheidegger & Spiess
Editor: Köbi Gantenbein
© 2009 Verlag Hochparterre and Verlag Scheidegger & Spiess AG,
Zurich
ISBN 978-3-85881-235-3
www.hochparterre.ch
www.scheidegger-spiess.ch